Experiencing the Art of Pas de Deux

UNIVERSITY PRESS OF FLORIDA

Florida A&M University, Tallahassee
Florida Atlantic University, Boca Raton
Florida Gulf Coast University, Ft. Myers
Florida International University, Miami
Florida State University, Tallahassee
New College of Florida, Sarasota
University of Central Florida, Orlando
University of Florida, Gainesville
University of North Florida, Jacksonville
University of South Florida, Tampa
University of West Florida, Pensacola

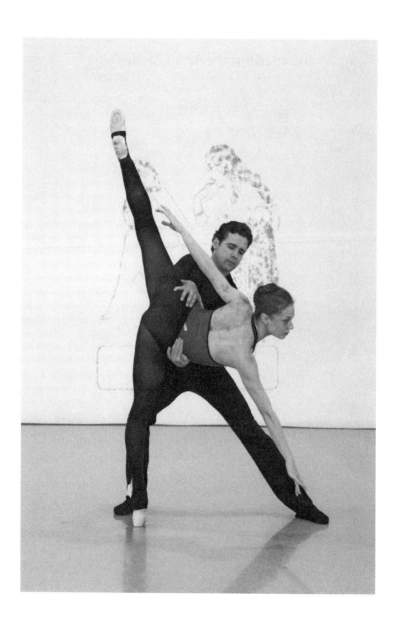

Experiencing the Art of

Pas de Deux

JENNIFER CARLYNN KRONENBERG
AND CARLOS MIGUEL GUERRA

Foreword by Philip Neal

University Press of Florida

Gainesville · Tallahassee · Tampa · Boca Raton
Pensacola · Orlando · Miami · Jacksonville · Ft. Myers · Sarasota

Scan the QR codes found throughout the book with your phone to be directed to how-to videos created by the authors. Full URLs to the videos are below:

Two Handed Promenade in Ballet
https://youtu.be/6XOcMwo1x2U?list=PLTRM_dcxA8rnYrtbI7JeRMY1UsGvW2f2V

Finger Turn into Grip in Ballet
https://youtu.be/P-v3hVFhdkM?list=PLTRM_dcxA8rnYrtbI7JeRMY1UsGvW2f2V

Learning a Series of Pirouettes
https://youtu.be/bkvDIXmk3jk?list=PLTRM_dcxA8rnYrtbI7JeRMY1UsGvW2f2V

Arabesque Press Lift in Ballet
https://youtu.be/M1E0Havijlo?list=PLTRM_dcxA8rnYrtbI7JeRMY1UsGvW2f2V

Ballet over Shoulder Lift from First Arabesque
https://youtu.be/aqgTKB-6tjM?list=PLTRM_dcxA8rnYrtbI7JeRMY1UsGvW2f2V

Learning a Series of Ballet Lifts
https://youtu.be/_yG5q3FQ-yE?list=PLTRM_dcxA8rnYrtbI7JeRMY1UsGvW2f2V

Ballet Shoulder Sit from a Running Start
https://youtu.be/AbGCgD3ISII?list=PLTRM_dcxA8rnYrtbI7JeRMY1UsGvW2f2V

Lift and Flip Combination in Ballet
https://youtu.be/SqR_XbC__zA?list=PLTRM_dcxA8rnYrtbI7JeRMY1UsGvW2f2V

Ballet Partnering Lift with No Arms
https://youtu.be/5an-orBtszk?list=PLTRM_dcxA8rnYrtbI7JeRMY1UsGvW2f2V

Flip from One Arabesque to the Other
https://youtu.be/PGtrfSyHvNk?list=PLTRM_dcxA8rnYrtbI7JeRMY1UsGvW2f2V

Back to Back Ballet Lift
https://youtu.be/jpO5COtyGok?list=PLTRM_dcxA8rnYrtbI7JeRMY1UsGvW2f2V

Combination of Moves in Ballet
https://youtu.be/L--BAqJ9njU?list=PLTRM_dcxA8rnYrtbI7JeRMY1UsGvW2f2V

A record of cataloging-in-publication data is available from the Library of Congress.
ISBN 978-0-8130-6292-1

The University Press of Florida is the scholarly publishing agency for the State University System of Florida, comprising Florida A&M University, Florida Atlantic University, Florida Gulf Coast University, Florida International University, Florida State University, New College of Florida, University of Central Florida, University of Florida, University of North Florida, University of South Florida, and University of West Florida.

University Press of Florida
15 Northwest 15th Street
Gainesville, FL 32611-2079
http://www.upf.com

For Meredith who, like us,
believed in the value of a different kind of partnering book.

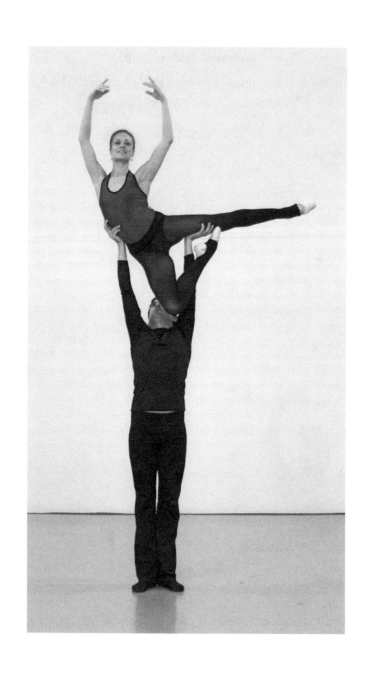

Contents

Foreword

While ballet continues to evolve, drawing upon an array of dance styles to explore infinite possibilities, the essentials of a thriving partnership remain refreshingly traditional. The *pas de deux* requires a heartfelt connection, sensitivity to another's physical and psychological needs. Dance is transcendent when two performers become one and calibrate equilibrium between the choreographer's vision and their own dramatic instincts. Lifelong friendships are formed, and on occasion, as with Jennifer and Carlos, a marriage.

Over the course of a 23-year career with New York City Ballet, I cultivated significant relationships with extraordinary ballerinas. Part of that longevity stemmed from an ability to adapt to the preferences of my partner. I could anticipate Kyra Nichols' unrivaled musicality, giving her space to luxuriate in a phrase or to charge forward with abandon. Our reliance was unspoken and unwavering; we never discussed or reviewed a step in those last moments before the curtain rose. The indefatigable, incomparable Wendy Whelan loved to joke during rehearsals, and I was only too happy to oblige. I imagined us the "Will and Grace" of Lincoln Center, full of witty backstage repartee that only comes with decades of unconditional love. Jennifer Ringer and I, two well-mannered Southerners living out their dreams in the Big Apple, empowered each other with a mutual calm. The thousands of people in the audience would melt away when her big brown eyes stared into my soul. And my "kid sister" Maria Kowroski, whose vulnerability belies her commanding facility, genuinely appreciated my guidance and reassurance. I loved helping her meet her

phenomenal potential as we discovered new heights together, bonding over exhaustive rehearsals.

While I am sometimes nostalgic about certain performance milestones, what I miss most is the intimate trust I formed with my colleagues in the dance studio. And it's that quality I strive to recapture in choreographing my own dances, as well as in staging the landmark ballets of George Balanchine and Jerome Robbins. I adore choreographing on a couple who will not only execute the step I've given but will also delve deep into where the step might next lead them—a truly collaborative process. And I relish the moment when dancers grasp the brilliant intent of a Balanchine or Robbins creation, making a masterpiece seem freshly minted. The daily rigors of a life in ballet can make for an insular world, some days triumphant with progress, others rife with defeat. But eventually it all culminates in an escape into performance that seems to pass in a nanosecond.

Jennifer and Carlos represent all that is glorious in a highly evolved collaboration between stellar artists. Their own *pas de deux* grew into a passionate partnership on and off the stage, and I've witnessed their constant attention to nurturing that delicate balance. Their shared experiences should benefit any aspiring dancer and serve as a model in the never-ending quest for perfection that is ballet. And isn't it great to have a partner to help you down that path?

Philip Neal
Former Principal Dancer, New York City Ballet
Artistic Director, Next Generation Ballet
October 2, 2015

Preface

~

Pas de deux, as described in the French ballet vernacular, directly translates into English as "steps for two," but it is better known among dancers as "partnering work." As in the development of all of the arts, a steady evolutionary path has allowed partnering to advance tremendously over the years, both technically and artistically. Though partnered dance plays an integral role in several styles and genres, in ballet specifically its traditionally obvious objective is to serve the ballerina. From a purely physical standpoint, *pas de deux* work presents her with a means to achieve significantly greater "awe inspiring" feats than she would otherwise be capable of. Supported by a partner, a ballerina is able to complete more *pirouettes* (turn around on one leg for a greater number of revolutions), hold sustained single-legged balances for longer periods of time, and achieve greater elevated height during jumps. As a rule, dancing with a dependable male partner will also grant the ballerina the freedom to more "effortlessly" maximize her range of motion, allowing her to stretch her technical line and artistic skill to their maximum effect while maintaining an unwavering façade of otherworldly grace and weightlessness. The male will typically be in control, guiding the ballerina's movements and steps, but his approach will not be haughty or aggressive. Rather, it should poignantly reflect a position of reverence toward the ballerina.

Originally designed as a simple bouquet of conventionally connected steps, *pas de deux* of the past served as *divertissements*, "diversions" or amusing interludes, within a larger ballet or dance. But *pas*

de deux work continually progresses. Today it could easily be considered a complex art form in and of itself. Society's ever-growing hunger for excitement has inspired many present-day choreographers to stretch traditional technical boundaries and capitalize on dancers' highly evolved athletic capabilities. Their resulting creations consequently tend to require partnering skills infinitely more demanding than the usual textbook basics. Because dance will always be a classically traditional art form, it goes without saying that the fundamental building blocks and framework of partnered dance will remain constant, and they will forever serve as the base and theme from which newer variations are derived. Nevertheless, today's dancer should be aware that intermittently they will be expected to reach much farther than those basics and required to expand their repertoire and skill set well beyond the conventional perimeters of the classics.

To both the trained and untrained eye, the formal *Grand Pas de Deux* that dancers become acquainted with in school (in *The Sleeping Beauty, Don Quixote, Coppélia, The Nutcracker,* and the "Black Swan Pas de Deux" in *Swan Lake,* for example) all resemble one another a great deal, regardless of differences in background and storyline. The choreography almost always includes a string of familiar and predictable steps, a "partnering alphabet" so to speak. Though the order generally varies, the steps themselves are quite predictable. One might also notice that the coda (the final segment in a *Grand Pas de Deux*) is characteristically a smorgasbord of "tricks" that, in several of these classics, are nearly identical. In today's *pas de deux,* structure and significance have changed and continue to change. More and more often, *pas de deux* are being created as comprehensive and conclusive entities, existing as complete ballets in and of themselves. They are also frequently designed to serve as the central section or "substance" of a bigger ballet. This is a huge testament to the newfound intensity of responsibility that a *pas de deux* can bear and to the depths of dramatic storytelling that even abstract partnered dance now possesses. Formerly the product of a language with limited vocabulary, partnering has now adopted diverse dialects to meet its new commissions, entertaining endless possibilities and conceivable

modifications. The rules and confines of classical ballet are constantly being challenged, tested, and even broken. Various dance styles and genres are being fused together, and new precedents are regularly being set. Especially difficult for those not entirely fluent in the formal basics, today's dancers must quickly and proficiently adapt to newer "contemporary" movements, often without significant experience. They will be expected to openly accommodate themselves to assorted partnerships (including unconventional ones), sometimes at a moment's notice and with limited time to rehearse. A dancer must be ready, willing, and able to meet the ever-growing expectations and demands of innovative choreographers and primed to keep up with the progressive pace of the work.

In times past, a male's strength was paramount in partnering work, as his role was mainly that of a porter doing the "heavy lifting." A tall, strong Premier Danseur would typically be considered a "good" partner, simply on the basis of his stature and physical capabilities. The higher he could lift and toss and the more easily he could "control" the woman, the greater his talents were deemed to be. Today's *pas de deux*, by comparison, are shying away from such reliance on a male's brute strength. Whereas many lifts have evolved into much more complicated, challenging versions of themselves, what now gives a *pas de deux* its brilliance is a consistency of commitment, contribution, and effort from both the male *and* female. Dexterity, awareness, sensitivity, intuition, and commitment will be constantly demanded from both partners. While strength and technique have certainly maintained their significance, building true distinction and merit in partnering skill now requires much, much more. Unfortunately, as textbooks and classroom studios focus mainly on teaching physical technique, they all too often neglect to address some of dance's most crucial, yet less obvious, partnering principles. Developing clear communication skills and steadfast patience are paramount. Understanding the importance of mutual honesty, manners, and respect will prove vital. Rarely ever addressed are the various options and avenues that couples can explore together to form secure relationships and build mutual trust.

As dancers professionally engaged in the art form, we find ourselves constantly asked to reach outside our own comfort zones, from ballet to ballet and from season to season. We *absolutely* do not feel we have mastered the art of partnering, as that would imply there is nothing more to learn. We admittedly continue to explore different options within our own work every single day. We write this book very humbly, *as* dancers *for* dancers, with the sole purpose of sharing our collective experiences with those who strive to keep learning, experimenting, making mistakes, and discovering every day on their road to improvement, just as we do. By generally addressing choreographic, artistic, and emotional issues through specific examples of challenges that we have personally faced, we hope to unveil certain "management" strategies we have found to be the most efficient. Going beyond straightforward textbook instruction, we will reveal some of the invaluable interpersonal lessons we have learned through firsthand experience in our years of dancing together.

We do not believe that partnering can be properly taught or learned following intermediary instruction in a book or on a video alone, no matter how precise or detailed the descriptions may be. We ask our readers to keep in mind that while there absolutely are certain standard practices, the intricacies that each dancer and set of partners deem most valuable and effective will surely vary. The tips and techniques found in this book are provided with the singular intention of enhancing what one may already be learning and practicing in the classroom studio and working environment.[1] Our particular tricks of the trade may not ultimately be what serves every dancer best, but we do hope, at the very least, that they may provide a pathway to new thought, discussion, experimentation, and discovery.

1 In the interest of physical safety, please do not attempt anything described or demonstrated in this book, its accompanying photographs, or videos, without proper supervision. Always have a teacher, coach, or other experienced professional standing close by, ready to spot and to offer assistance as needed.

1

Introduction

The Evolution of Partnering

A brief look at the origin and progress of the pas de deux

We firmly believe it is impossible to fully appreciate an art form or understand where its development currently stands without some familiarity with its history. Lacking such awareness, it is harder still to fathom an art form's potential or the possibilities for its future. For these reasons, let us begin at the beginning by discussing the origin of what is known as *pas de deux*. The term *pas de deux* means "steps for two," but it actually encompasses so much more than just the coupling of two dancers. *Pas de deux* as we know it involves extensive partnering work, including, but not limited to (in layman's terms), lifting and carrying, turning, promenading, dragging, and counterbalancing. The two dancers, as a team, are responsible for the success of the dance. Accordingly, the term *pas de deux* has a very particular connotation in today's dance world. Inevitably a prototypical classical *Grand Pas de Deux* pops into mind, arranged as an introduction, an adagio, a solo variation for each of the dancers, and finally as a coda. The gentleman is often responsible for being the woman's stalwart support—in effect a human *barre*—as he assumes an assortment of positions, allowing her to place her weight on him, using his body as

her anchor. He will also serve as her porter, carrying her around the stage as she moves through one position into the next. Interestingly the *pas de deux* of centuries past were structurally quite different from those we associate with the classical tradition, and most modern-day *pas de deux* have evolved well beyond this standard form as well.

⁓

The concept of the *pas de deux* is thought to have originated from the social couples dances performed in the courts and ballrooms of European monarchs. Not formally translated into showpieces until the early eighteenth century, they were customarily placed at the beginning of a ballet or opera and generally didn't involve any complex partnering work at all. They were fairly simple and unpretentious, routinely consisting of a couple dancing within close radius of one another, executing the same choreographic steps. Periodically the dancers might connect by taking hold of each other's hands, but this was not a requirement.

It was not really until the turn of the nineteenth century and the dawn of the romantic era that the more conventional *pas de deux* blueprint developed. *Pas de deux* adopted increasingly theatrical and dramatic tones and, rather than solely dancing a series of steps to the music, dancers would portray actual personae, expressing their characteristic qualities—their virtues and frailties—through their steps. Partners began acting out romantic story lines, and gender roles were clearly demarcated.

With the exception of works by the renowned Danish choreographer August Bournonville (whose ballets reflected his own distinct style and were appreciated for their joyful liveliness and youthful buoyancy), dances of the romantic period called for more complex physical interaction. Dancers began negotiating with hands-to-waist support, inspired by the introduction of dancing *en pointe*, presumably by Maria Taglioni. (One of the most notable ballerinas of romantic ballet, she was lauded for originating her role in *La Sylphide* at the Paris Opera Ballet, dancing on her toes or *sur les pointes*.) As

more ballerinas began negotiating this new, sophisticated level of difficulty, they discovered that they were capable of greater feats when firmly supported by their male partners. Accordingly, the primary role of the male dancer around this time became that of assisting the ballerina. These transitions comprise the birth of what we think of as "traditional partnering" in ballet today.[1]

Later, well into the mid-nineteenth century, dancers continued to stretch their technical limits. Their artistry became increasingly refined, and men's roles became more prominent and athletic. As a result *pas de deux* work naturally progressed, gradually turning into an art form within an art form. By the latter part of the nineteenth century, full length ballet productions frequently began showcasing a *Grand Pas de Deux*, often considered to be the highlight of the performance. These *Grand Pas de Deux* would eventually become the most prominent and recognized segment of many full-length works.

Called the "father of classical ballet" and regarded as probably the most influential choreographer in ballet's history, French choreographer Marius Petipa (1818–1910) is still revered in today's dance world for many of his celebrated *Grand Pas de Deux*. These consistently adhered to what is considered the traditional *pas de deux* structure: a partnered adagio followed in turn by a male solo variation, a female solo variation, and concluding with a dazzling coda. The *Grand Pas de Deux* he created, mainly during his long career with the St. Petersburg Imperial Theater in Russia, are renowned as tremendous platforms for prima ballerinas and their *premier danseur* cavaliers, and they were highlights of Petipa's most famous ballets, including *Swan Lake, Don Quixote, La Bayadere,* and *The Sleeping Beauty.* The *Grand Pas de Deux* from most of these works remain so technically and artistically substantial that today they are often performed on their own, detached from the ballets in which they originated. Some of his best known *pas de deux* were actually maintained and passed

1 Kenneth Laws, *Physics and the Art of Dance: Understanding Movement* (New York: Oxford University Press 2002), 104–5.

down in exactly this fashion, as independent works. Regular staples of gala performances, festivals, competitions, and company repertory, *Diana and Actaeon, Grand Pas Classique,* and *Esmeralda Pas de Deux* (after Russian choreographer Lev Ivanov) are just a few noteworthy examples of such stand-alone pieces. Petipa's *pas de deux* primarily showcased the prima ballerina and, with the exception of his solo variation and a short virtuoso bit in the coda, the cavalier's role often involved little actual dancing. The adagio was mainly a platform for the ballerina to show off *her* artistic skill.[2]

August Bournonville (1805–1879) did not adopt the romantic grandeur of Petipa's *pas de deux* style, maintaining instead an elevated discretion. In their reserved use of physical contact, Bournonville's *pas de deux* reflected, perhaps, his allegiance to the social decorum of the eighteenth century rather than to the extravagances of the romantic era. They typically demonstrated less hands-on partnering and more of a balance in the dancing itself: neither the man nor the woman appeared more prominent than the other. The dancers' individual passages were also generally showcased in a courteous, uncompetitive manner. The dancers often performed their steps together, side by side, only occasionally connecting hands to hands or hands to waists. It was sometimes necessary for the gentleman to offer support to the lady, but not extensively. The *pointe* shoe had only just been introduced, and though ballerinas were wearing them in his pieces, Bournonville typically refrained from incorporating many challenging lifts and steps *sur les pointes.* This is demonstrated in his *pas de deux* for *Flower Festival in Genzano,* for example. While the lady's choreography is difficult, it consists mainly of small jumps (*petite allegro*) and work on *demi-pointe* (half toe). During the main body of the *pas de deux,* the man was often given just as much room as the ballerina to flaunt his dazzling technique. As a tribute to his own impressive dancing skills, Bournonville's *pas de deux* generally proved to be great vehicles for male dancers, challenging them dramatically

2 Selma Jeanne Cohen, *International Encyclopedia of Dance* (New York: Oxford University Press, 20sty04), 105–8.

and technically and calling for the mastery of brilliant footwork and seamless precision and control.[3]

Increasingly complex acrobatics made their way into ballet and *pas de deux* work during the early twentieth century, introduced by none other than the skillful Russians. This additional element inspired many of the big and exciting lifts seen in *pas de deux* of the century and continues to inspire work today.[4] Dancer and choreographer Mikhail Fokine (1880–1942), a man of multiple artistic talents as a student and teacher with the Imperial Ballet School in Russia, worried that the art of ballet might become overly acrobatic and "degenerate into mere gymnastics."[5] Viewing dance as an art form that should transcend gratuitous virtuosities, Fokine instead favored their sparing use solely as a means to bolster expressiveness and interpretation. Fancy acrobatics undeniably drew audiences, however, and his revolutionary concerns and proposals were met with indifference by the directors of the St. Petersburg Imperial Theater in Russia. They were openly welcomed, however, by the formidable ballet impresario Serge Diaghilev and the company he founded, the Ballets Russes. As the first principal choreographer for the Ballets Russes, Mikhail Fokine created several ballets and their accompanying *pas de deux* with his own revolutionary style. They demonstrated a rich sensuality and fresh equality between the two dancers, and were a platform for male dancing. *La Spectre de la Rose, Les Sylphides, Scheherazade, The Firebird*, and *Petrouchka* are just a few significant examples of some of his most famous works.[6]

While the famous *pas de deux* of previous centuries often strove to balance male and female roles and to enact equality in dance, the whole notion of gender equality in dance was challenged in mid- to

3 *Bournonville.com* (http://www.bournonville.com). See "The Style," particularly, "Bournonville's Choreographic Style" by Knud Arne Jürgensen.

4 Kenneth Laws, *Physics and the Art of Dance: Understanding Movement* (New York: Oxford University Press 2002), 107.

5 *Michelfokine.com* (http://www.michelfokine.com). See "Biography," particularly "Michel Fokine–Fokine Estate Archive" by Isabelle Fokine.

6 Susan Au, *Ballet and Modern Dance* (London: Thames and Hudson, 2002), 80–81.

late twentieth-century America by George Balanchine, probably the most productive choreographer of his time. Considered the father of American ballet by professionals throughout the dance world, presumably for his extensive use of neoclassicism, he provocatively professed, "Ballet is woman." One of his best-known statements perfectly describes his point of view: "The ballet is a purely female thing; it is a woman, a garden of beautiful flowers, and man is the gardener."[7] While Balanchine created artistically brilliant and remarkably challenging male roles within several of his ballets, the majority of his *pas de deux* seem to require that the gentleman, or *danseur noble*, remain practically invisible to the audience: "In my ballets, woman is first. Men are consorts. God made men to sing the praises of women. They are not equal to men, they are better." Accordingly the male dancer typically attracts little or no attention and seems to exist solely to showcase the ballerina during the length of their dance together. Take *Concerto Barocco*, for example, in which the leading (and singular) male dancer first enters the stage at the start of the ballet's second movement to graciously partner the principal ballerina. As the sole man in the ballet, he has the privileged responsibility of moving her through what is arguably one of the most gorgeous adagios in existence. At the end of the movement he disappears, not to be seen again. He is given no variation, no coda, and no true "steps" of his own.

Carlos and I have danced this adagio from *Concerto Barocco* many times, both together and with other partners, and it is one of the longest, most beautiful, and most taxing adagios we have ever performed. For true efficacy, the partnering work must be executed gently, elegantly, and seamlessly. As demanding and tiring as the movements are, they need to appear effortless. When the *pas de deux* begins, the ballerina is already fatigued from the brisk, nonstop choreography of the first section—an added element of challenge for both partners. Though the man may not have any real steps to speak

7 See Rachel Beaumont, "'I am a cloud in trousers': The Sayings of George Balanchine," *Royal Opera House*, April 25, 2013 (http://www.roh.org.uk/news/i-am-a-cloud-in-trousers-the-sayings-of-george-balanchine).

of, this is undoubtedly one of the most difficult ballets he will ever have the pleasure of performing. The audience may never realize the great demands placed on him, and he may ultimately receive little of the final credit. Without a doubt, this ballet calls for a man who is a highly sensitive, technically and artistically intuitive expert. We personally consider this *pas de deux* not only as a choreographic *revérénce* (bow) to woman, but also as a tribute to what Balanchine must have believed the incredible capacity of a great male dancer to be. While we have encountered a few male dancers who seem to take umbrage at being subordinate to the ballerina (referring to themselves as "haulers," "tractors," and "cranes"), there are also *many* who regard caring for the beautiful "flower" that is the ballerina as the greatest of honors. Ultimately, from the dancer's perspective (and the viewer's), "equality" and "significance," just like "beauty," lie within in the eye of the beholder.

In addition to Balanchine, the twentieth century gave rise to a host of eminent choreographers around the world: Britain's Antony Tudor and Sir Frederick Ashton; America's Jerome Robbins, Twyla Tharp, Paul Taylor, John Neumeier, and William Forsythe; South Africa's John Cranko; Spain's Nacho Duato; France's Roland Petite and Maurice Bejart; and the Czech Republic's Jiri Kylian. The list goes on and on. The innovative genius of all of these "creatives" helped guide the art of *pas de deux* into the twenty-first century. Russian *pas de deux*, long famed for exciting acrobatics (consider twentieth century examples such as *Spartacus* and *Spring Waters*) are apt to remain as visually stimulating and technically exciting as those of centuries past. Nonetheless, we believe that it is the artistic subtlety evinced in dances created by the choreographers named above that has advanced the *pas de deux* as the polished and delicately refined art that it is today.

Beyond Russia, mid- to late twentieth-century choreographers also experimented with virtuosic lifts but, presumably, with new intent. Such moves were used more to enhance the artistry of partnering than to show off dazzling stunts. Choreographically speaking, partnering became considerably more delicate in the way women were

maneuvered and handled by the gentleman. Such gentility especially characterizes Balanchine and Ashton works, where the ballerina is often lifted and carried. She will be held and suspended gracefully in the air for substantial periods of time in an array of positions. Rarely if ever will she be forcefully thrown or tossed, spun around violently, or caught from mid-air in a wildly acrobatic manner. Instead, amplified emotional connection, intensified awareness, and genuine sensitivity between partners became paramount in late twentieth-century choreography. The couple gave the impression that they were not only dancing for the audience but for each other, conversationally. This manner and style was not only found in newer choreographies but was translated into the restaging of older works as well. In response to this trend, from the mid- to the late twentieth century some of the most beautiful and iconic dance partnerships were born: the Royal Ballet's Margot Fonteyn with Rudolph Nureyev and Antoinette Sibley with Anthony Dowell; New York City Ballet's Patricia McBride with Edward Villella and Suzanne Farrell with Peter Martins; Stuttgart Ballet's Marcia Haydee with Richard Cragun; American Ballet Theater's Gelsey Kirkland with Mikhail Baryshnikov and Cynthia Gregory with Fernando Bujones. The chemistry these duos shared onstage took any piece of choreography to greater heights. Whether subtly understated or full of bravura, these dancers consistently engaged in their dialogue of movement with tender familiarity and an elusive intimacy.

The young twenty-first century has already gifted us with many talented choreographers, including Val Caniparoli, Edwaard Liang, Trey McIntyre, Justin Peck, Alexei Ratmansky, Liam Scarlett, Septime Webre, and Christopher Wheeldon. They all continue choreographing classical, neoclassical, and contemporary *pas de deux* that are genuinely mind-blowing in their ingenuity and demand for physical skill and artistic depth. The art of *pas de deux* will undoubtedly continue to change and advance just as dancers, choreographers, and audiences go on developing and maturing. Social and ballroom dance have become more and more accessible through televised reality shows and competitions, and while ballet *pas de deux* techniques

have been incorporated into these programs on many levels, so have new ballets and ballet companies incorporated the art of social dance partnering into the standard *pas de deux*. This fusion is proving wonderfully progressive: there are many similarities to be found within these different styles, and there is much to be learned and gained from experimentally integrating them all. Even jaw-dropping athletic spectacles such as Cirque de Soleil now increasingly incorporate ballet dancers and traditional *pas de deux* work into their shows.

At the end of the day, *pas de deux* in any of its forms is one of the most touching, appealing, and humanly accessible vehicles of expressivity through dance. Whether the style is informal, improvisational, traditionally social, or technically structured, great partnered dance is *always* a fascinatingly mindful synergy between two artists on the deepest human levels: mental, physical, and emotional. As expression through artistic imagination intensifies, the physical capabilities of dancers will continue developing, and the mysteries that lie within emotional relationships will unendingly be explored. With these serving as constant inspiration, the potential within the art of partnering should prove endless.

2

~

The Artistry within Partnering

The importance of discovery and development beyond technique

In just about any style of partnered dance, whether ballet, ballroom, tango, ice dancing, or informal salsa, it is rarely the obvious (meaning, the steps themselves) that is ultimately responsible for entrancing spectators. Instead, a pair's approach to the tiniest of details *within* the actual partnering work will ultimately set one couple apart from the next and keep audiences on the edges of their seats longing for more. Such nuance is typically derived and developed through the artful intelligence, tailored partnering style, and dramatic instincts of the individual dancers. Many feel that a dancer's innate talent and temperament will have a significant influence on his or her partnering style. We have found this to be true in certain instances, but we also believe that technical distinctions and stylistic individualities can be consciously learned, practiced, and developed—just like any other aspect of dance. These refinements truly have the potential to enhance one's partnering abilities and may help transform a promising bouquet of technical skills into a maturely developed and unified art.

The vast array of actions and emotions within a *pas de deux* can prove incredibly intense and extraordinarily delicate simultaneously.

Whether it is the slightest of smiles, a stolen glance, or even something as seemingly trivial as the placement of fingers, it is often a dancer's attention to minute details that has the power to make or break a *pas de deux*. As a couple, we have always invested significant time and energy concentrating on exactly these elements. Our rehearsals are never solely focused on perfecting the choreography we must execute; rather, they tend to be about what we wish to achieve *overall* and what our plan of action should be. We first discuss in detail our general intent: exactly what we would like the audience to feel, to comprehend, and to take away from our performance. We then try to settle on a harmonious "game plan" that will lead us most efficiently in that direction. Having our aspirations and objectives clarified right from the start allows us to use our time economically and leads to productive rehearsals.

Anton Dolin, famed British dancer of the early nineteenth century, is known for his extraordinary partnering expertise. He states in his book *Pas de Deux: The Art of Partnering*, "Great Ballet, like great theater depends upon the collaboration of its artists; I think that it is in partnering that this collaboration, because of the complexity of the minutest detail, attains its most complete fulfillment."[1]

When partners strive to develop artistic distinction on physical, musical, and dramatic levels, they should expect that intentions and tactics will vary with one pairing to the next. This is true at even the simplest of levels. For example, one pair may take a basic approach to a *promenade* (the gentleman walking steadily around the lady, rotating her as she balances on one leg) by simply going around in as balanced (or off balance) a way as they can as they prioritize speed in the interest of the produced visual and musical effects. Another couple may have the desire to advance this basic approach one step further in terms of *physical detail*. They may decide that their ultimate objective is for the lady to look as poised, delicate, and as lightly maneuverable as possible. Here is where we will find a significant

1 Anton Dolin, *Pas de Deux: The Art of Partnering* (Wilmington: Dover, 1969), 59.

difference in approach to the same step. The first couple will probably execute their *promenade* with a conventional hand-to-hand grip. While this grip is a secure and satisfactory choice, both traditionally and technically, the latter couple may choose to experiment. The gentleman may try using only his thumb and middle finger to hold the lady's wrists instead of her hands. This grip will allow them *both* the freedom to display their fingers, a technique often seen in the Balanchine style. Though more delicate (and to some, more beautiful), this grip may initially feel insecure, requiring more time and practice to perfect. If executed properly, the ballerina will appear to be floating ethereally as she is lightly and almost imperceptibly maneuvered by her partner. Eventually both couples will successfully accomplish their *promenade*: the former with security and distinct musicality, the latter with enhanced physical finesse.

Much of the artistry in partnering lies in the intrinsic conversation between the two dancers. Often ladies will "interrupt" their partner's "sentence," robbing him of the chance to initiate and continuously guide a sequence of movements. This is particularly common in ballet. Unlike social and ballroom dancers who regularly practice spontaneity and improvisation, ballet dancers are generally expected to memorize and execute specifically detailed choreography over and over again. Knowing exactly what is to come, step after step and beat after beat, often results in a natural urge to anticipate. Constantly rehearsing and performing the same passages with the same familiar partner to the same predictable music can easily cause a dancer to go on "auto-pilot," albeit inadvertently. By doing so, she will unintentionally disregard both the spontaneity of feeling and the depth of purpose within a *pas de deux*. Take the following example. A ballerina motions in acceptance of the gentleman's hand *before* he actually offers it and continues on to take an initial step in the direction she *knows* they will be going *before* her partner has shown his intent to lead the way. Dramatically speaking, she has just diminished both her own regality and his role as "the cavalier." In a second, more physical example, if a lady begins leaning off balance at her own whim instead

of waiting for her partner to ease her outward, she will have, in her hurriedness, stolen away her partner's chance to guide her smoothly off of her leg with seemingly effortless control. Caught off guard, he may have significant difficulty steadying and maneuvering her.

While neither of these two instances may seem enormously consequential, they are nonetheless useful illustrations of a female dancer's preceding her partner's initiatives, typically causing him to lag a split second behind her. Being thrown out of the driver's seat, he will be forced to play catch-up, sometimes fumbling in order to regain control. He may also have to take quick problem-solving actions should things begin to go awry in a domino effect.

These are also perfect examples of how easily two dancers can suddenly find themselves in the middle of a paradox: "partnering" separately, dancing a *pas de deux* as two individuals instead of as a single team. Though they share the stage and execute steps together, the emotional connection and overall chemistry between the partners will be lacking, regardless of their technical expertise.

Several of the elements that define the artistry in partnering may be instinctual, for both men and women. Certain dancers will find that they are remarkable artists in their own right, yet somehow lack the natural intuition necessary to being a great partner. However, many of these alleged instincts are actually learned skills instilled in some fortunate dancers from a young age. In several countries, such as Cuba and Russia, dancers begin *pas de deux* classes very early in their training. Sometimes *pas de deux* classes are mandatory even before the dancers have built enough strength to handle many of the physical demands (such as lifting) associated with the work. As a former ballet dancer herself, physical therapist Elizabeth Maples, DPT, notes, "Many of the injuries I treat are the results of accidents both directly and indirectly related to partnering. Students always seem so anxious to start *pas de deux* classes, but really, from a dance medicine standpoint it makes little sense to begin lessons prematurely. How can one be expected to dance correctly, safely, and efficiently with a partner when they are still in the academic stages of learning basic

technique, and still in the process of discovering how to hold themselves up on their own?"[2]

Early partnering training is undoubtedly a controversial subject. Despite the physical risks associated with it, however, if classes are properly managed, *some* young dancers' experiences may well prove valuable later on. With early exposure to intelligently structured, moderate *pas de deux* work, young dancers will generally acquire comfort and ease with it. By regularly working with a variety of partners differing in weight, height, and body type, they are apt to develop versatility and adaptability. Boys can become sensitive and attuned to each particular girl's physical axis, her center of gravity, and her shifts in balance, discovering for themselves the quickest, most efficient ways to accommodate these differences. Likewise, girls can find various techniques to help boys of varying heights and strengths support them, learning how to hold their bodies when paired with partners of limited physical strength and technical ability. Girls can also become considerably more comfortable with the idea of being manipulated by a partner and attuned to deciphering the numerous signals and physical cues each new partner will bring to the floor. Early intuitive development has reportedly contributed to the traditional renown Cuban male dancers enjoy as exceptionally strong, smooth, and knowledgeable partners. It has also led female Cuban dancers to be lauded for their fearlessness and unfaltering partnering strengths.

Much of the perceived mystery in the art of partnering lies in the unspoken bond formed between two dancers. Though not always adhered to as strictly as in formal social dance, the foundation of a strong "lead/follow" relationship is often considered the essence of a great dance partnership. Though "leading" and "following" are traditional, well understood terms in dance's vocabulary, in actual practice, the gentleman makes a physical "suggestion" to his partner, a cue that the lady must interpret and respond to. Neither of their roles is entirely passive or aggressive. A dancer's ability to successfully

2 Author interview with Elizabeth Maples, February 5, 2015, Miami Beach, Fla.

interpret his or her partner's signals will almost always depend on attentiveness, open-minded willingness, and mental flexibility. There is an intangible beauty and artistic sophistication to be gained when two dancers grow to understand each other intimately over time. A nurtured, slowly developed dance relationship has the power to generate a unique sense of confidence. This deep level of poised familiarity and trust typically allows dancers to enrich their partnering with unrehearsed and spontaneous personal flourishes. The gift of such unconditional assuredness between partners may prompt a pair to experiment with impulsiveness, introducing an element of fearless abandon into the restrictions of set choreography.

When two dancers work together to coordinate and to adapt to everything from their builds to their timing to their idiosyncrasies, they will find themselves on the road to developing a relationship. As they allow themselves to become symbiotic extensions of each other's movements, two individual dancers will organically morph into one. A successful dance partnership is, for better or worse, much like a marriage, calling for patience, understanding, cooperation, trust, loyalty, and, occasionally, submission. It is a relationship of equal opportunity. Both dancers must take ownership of their actions and acknowledge that the success of their *pas de deux* lies in a true team effort. Indulging egos will serve no purpose. The dancers must be willing to share the stage, the spotlight, and the workload. There is no master, no servant. Whether initiating or responding, both parties will share proportionate purpose and responsibility for the unfolding of the dance. There must be a commonly shared priority and a mutual shift in focus from each individual's personal triumph to the success of the couple as one. Development of trusting relationships between dancers will allow for bold experimentation and growth within partnerships and *pas de deux* work. This verity has informed differing dance styles and genres for centuries, and it continues to the present. It *is* the beating heart of partnering and what will keep distinguishing *pas de deux* work not only as a technique but as an art form in its own right.

3

The Makings of a "Good" Partner

Understanding which characteristics to strive for

Every dancer has distinct opinions and personal preferences concerning the attributes of an ideal partner. In *pas de deux* work, the immeasurable adjustments and modifications, both physical and emotional, that a couple must be prepared to make directly reflect the delicate compromises that help nurture and sustain all of life's meaningful relationships. Cooperation truly is the name of the game. Free-flowing positive and harmonious energy will help most dancers feel at ease. Particularly in circumstances requiring the male to step out of the spotlight in deference to his partner, it is wisest for both dancers to check their egos at the door.

In ballet, especially for a male dancer, partnering work may not seem as riveting as dancing a solo variation with exciting turns, jumps, and bravura "tricks." *Pas de deux* work is a studied art *within* an art, and while some gentlemen will take great pride in the responsibility of showcasing their partners, others may find little glamour in it. In spite of one's natural hauteur, however, it is a cavalier's foremost duty to help his partner feel comfortable and confident at all times. In fact, the quality of her performance will be measured in large part by his partnering proficiency. He must be precisely attuned to the

slightest variance in her balance from day to day, minute to minute, and he must be confident, forward thinking, and decisive in his actions to assist her. He will be able to serve her well, but only to the extent that he deems her performance his priority. In exchange for the gentleman's gallantry, a lady may graciously show appreciation for his efforts (and sacrifices) by exhibiting patience, calm, and adaptability, recognizing with gratitude that dancing with a partner allows her to accomplish feats she would probably be unable to achieve on her own. With a partner's assistance she has the enhanced ability to do more *pirouettes*, jump higher, balance longer, travel further. The list goes on. Regardless of who seemingly dominates the spotlight, in reality it will be neither individual but the pair as a team. A successful *pas de deux* is always the product of a mutually respectful reciprocity between the two dancers.

In striving to enhance one's partnering skills in most dance genres (including cheerleading, ice-dancing, and social dancing), one must develop a heightened sense of awareness or a "sixth sense." In the greatest partnerships, two dancers will share a unique rapport and the ability to read and sense each other's needs with split-second timing. They will understand each other's tendencies and habits, instinctively knowing where a balance should be, how many *pirouettes* to do, when to offer more (or less) support, and how to interpret differences in musicality and timing.

Renowned in the ballet world for her easy grace, strength, and technical skill, Maria Teresa del Real, former prima ballerina of the English National Ballet, has partnered with some of today's most celebrated male dancers, including Rudolph Nureyev, Fernando Bujones, José Manuel Carreño, and Carlos Acosta. Incredibly they are just a few of several great partners with whom she was able to build truly intuitive relationships. Finding these connections magical, she distinctly remembers how they evolved: "As we worked through the technical and artistic aspects of the choreography, we would begin to automatically sense each other's needs. The interpretation of our dance would then have the freedom to deepen with each rehearsal.

Our partnering would steadily grow into a symbiotic exchange of energy—creating an effortless flow, and a beautiful physical melody."[1]

Naturally Ms. del Real was not paired with her "ideal partner" in every circumstance, especially as she was often invited by companies to dance as a guest artist. At times, being entirely unfamiliar with her partner caused her great apprehension:

> I would arrive, and we would have to rehearse intensely on our own for a few days before joining the full company rehearsals, which were often quite close to the opening night. If my partner was particularly young, or inexperienced, I would have to take extra care into putting him at ease, trying to be as technically strong as possible so as not to rely on him excessively. I also encountered some gentlemen who danced beautifully on their own, but were especially clumsy in their partnering, at times even putting me way off my leg . . . but what was truly the most awful, as well as unproductive, was to be paired with a dancer who was selfish in his working style, insisting on doing things only his own way . . . or with someone entirely preoccupied with himself rather than looking after the ballerina. Though theses complications proved extremely annoying to contend with, they are actually an unavoidable part of a dancer's professional reality.

The beauty of live performance means that each show (or competition, as the case may be) will be different, with entirely unique circumstances to negotiate. Like partners, no two events will ever be exactly alike. Dancers must learn to be aware of and to adjust to such variables together as a team, in the moment, with little or no discussion. Each one of the pair will be obligated to pay attention to all possibilities related to their partner and surroundings. They will also be responsible for accommodating themselves to a certain degree of inconsistency. Accommodation is a talent that, like most, can

1 Author interview with Maria Teresa del Real, September 27, 2014, Miami, Fla. All del Real statements are drawn from this interview.

be developed, though some dancers will find it comes more naturally than other talents. This is where honest communication comes into play. Neither partner should be afraid to speak his or her mind. As long as comments and critiques are gently and constructively conveyed, both dancers should be willing to openly address them in the interest of improving as a team.

Naturally the confidence to communicate freely comes easiest when two people already share a level of comfort with one another. Dancers getting to know each other off the stage and out of the studio is a promising first step. Simply engaging in friendly collegial conversation will usually help a couple gain new perspective on and insight into one another's personalities, which may assist them later in developing a stronger and more satisfying working relationship.

Reversing roles from time to time can also be an interesting way to cultivate new understanding and appreciation between partners. This approach may prove especially helpful when partners find themselves struggling to understand how best to help each other. Sometimes, by putting himself in her place, trying to experience firsthand what she is feeling and trying out her choreography for himself (with another gentleman supporting him if necessary), the man may more easily comprehend how the woman needs to be assisted. Likewise, by placing her hands on her gentleman as he marks her steps (never attempting lifts or other heavy partnering, which could lead to injury) the woman may acquire insight into what her partner feels when he is behind her, and she may better understand what she can do to make his life easier. Carlos and I do this role switching frequently, and though it sometimes feels quite silly, it has really helped us empathize with one another's concerns and frustrations.

Occasionally the interpersonal chemistry may feel slightly "off," and the partners may not seem ideally matched at first dance. Though they might find working together challenging, they should certainly not feel overly discouraged. With due time and effort, they may find that they *can* cultivate a great partnership together. In fact, with the investment of hard work and total commitment, initially awkward pairings often turn out to be incredibly successful. Chemistry usually

develops slowly and is not always apparent right off the bat. Indeed, even when a certain allure is evident at first dance, it will still take patience and diligence for dancers to build a truly solid partnership.

Whether male or female, great partners will be amenably inclined to take responsibility when missteps occur. Any variety of circumstances can make things go awry in partnering work, and while many female dancers have been taught to attribute mishaps to the "gentleman's fault," such blame is simply unfair as far as we are concerned. While accepting blame as if he were solely responsible is a noble gesture on a man's part, realistically it is unreasonable for a lady to constantly expect such gallantry. "It takes two to tango," as the saying goes. A lady should feel confident enough to approach her steps with a certain amount of abandon, and ideally her partner should be able to "fix" things when they go wrong. The truth is, however, that most adjustments are neither easily made nor seamlessly disguised. A lady should be equally willing to assume responsibility, accept fault, and offer up her apologies when they're due. Mutual acceptance of error is the only way to consistently improve as a couple. Such rapport will ultimately allow two dancers to become one with each other on stage, sharing the unique gifts of being extensions of one another's movement, breath, and timing. It is this intimate and respectful connection that is the essence of "good partnering," an essence that will ultimately produce the illusion of effortlessness, the ever-elusive goal for which all dancers strive.

4

The Power of Trust

The road to fostering mutual confidence

Concentration and focused commitment between partners throughout a dance has the potential to translate into a profound and impenetrable bond, a harmonious sophistication and powerful artistic statement. Unfortunately it is not uncommon for dancers to fall mindlessly into routine partnering, focusing solely on the technical demands of the choreography instead of on tuning into the specific (and sometimes varying) needs of their partners. This is what might be considered uncommitted, or "absentee," *pas de deux* work. There may be strong presence of body but not of mind when two people dancing together nonetheless dance separately, failing to genuinely connect, failing to truly trust. Given the physically taxing intricacies of today's works, two dancers must actively engage in an ongoing conversation to make convincing emotional impact on each other and on the audience. Essentially they must work together as one: one body, one mind, one soul, one entity. It is from this ground of mutual awareness that deep rooted trust between partners can arise and flourish.

In dance, the premise of how trust works can seem like a conundrum. Life dictates that giving trust beget trusts, yet placing complete confidence in another person can be terrifically difficult without a

prior *guarantee* of safety. Unwavering mutual confidence between dance partners rarely occurs right away. Typically the securest partnerships are those that allow the dancers to build, through work, a reciprocal, synergetic relationship steadily over time.

The word "trust" itself is often synonymous with "belief," "faith," "confidence," "conviction," "expectation," and even "reliance." While dancers are commonly advised that they *must* trust their partner, few are ever taught *how* to safely let go of their natural apprehensions to trust someone or what they themselves should project to successfully earn trust in return. Some will find it difficult to understand what "trust your partner" actually means. In our understanding, this overly general, even clichéd, statement suggests several important concepts. The woman must believe, without a doubt, that she can safely and securely place her life and career in her partner's hands. Though it may seem a huge exaggeration, in many instances she will feel as if she is doing just that. She must consider her partner truly worthy of handling tremendous responsibility and wholeheartedly accept his professional pledge to make her safety his first priority as he helps her reach the height of her potential. She must feel certain that her partner will always give precedence to her immediate needs, even at the occasional expense of his own comfort and vanity.

Similarly the gentleman must have faith that his ballerina will be steadfast and consistent in her artistic decisions: he must believe that she will have the wherewithal to remain *conscientious* in her abandon. He has to respect her professional pledge to maintain at all times a courteous awareness of and respect for his whereabouts, his being, and his efforts. He needs to place confidence in her judgment and acknowledge her ability to make practical and intelligent choices relative to the choreography, the circumstances, and his realistic capabilities.

Both dancers must unconditionally commit to relying on each other's competence and to respecting each other's weaknesses, learning to accept, without fear, the ever-present, unpredictable margin of human error. Might accidents happen? Yes, of course. In fact, they most certainly will. But as unwavering conviction is developed

between the partners *together*, as a *team*, the less likely most accidents will become.

As a married couple, it goes without saying that Carlos and I possess a unique and instinctive trust in each other, far surpassing any faith we have worked to develop with other partners. We know and understand each other intimately—inside and out, backwards and forwards. Nevertheless we have certainly had our fair share of mishaps. One incident, in particular, will forever remain clear in our minds. Though we had rehearsed and performed the sensual tango-inspired *pas de deux* from Paul Taylor's *Piazzola Caldera* several times and had become quite confident in it, there was one particular lift that always seemed to be a gamble with fate. As the lady pushes with her legs to propel herself from a seated position on the floor, the gentleman assertively pulls her up by her hands. She flies forward, aiming to land very high up on his chest. As he lets go of her hands to catch her rear with his own, her legs ideally should wrap cross-legged over his upper shoulders. If both dancers' timing and propulsion are not precisely coordinated, the results can be dangerous—as we discovered firsthand. I felt Carlos pull me up from the floor. Fearing that we were late, I pushed forward more assertively than usual. The excess momentum made for a rough landing, and Carlos abruptly stepped backward to counterbalance the impact. Usually as steady as a pillar, his sudden, uncharacteristic wobbling caused me to panic. Instinctively I squeezed my legs as tightly as I could around his neck, oblivious to the repercussions. As his neck cracked, Carlos temporarily blacked out and toppled to the ground. He lay still on the studio floor, motionless and unresponsive, as I stood beside him, horrified. Though his blackout lasted only a few moments, I feared my actions had paralyzed him. Regret coursed through me as fiercely as a raging river. Had I only *trusted* his ability to absorb the abrupt impact of my landing and recover quickly, the accident could have been avoided. I should have held both my composure and my position, allowing him leeway to regain his balance. My attempt to take total control of the situation out of fear ultimately knocked us down. We were both shaken by the incident, though thankfully neither of us was seriously

injured. It was, however, a swift and serious lesson on just how important unconditional, resolute trust is to a successful partnership.

Undoubtedly certain pairings will feel more immediately organic than others, naturally generating a relaxed, unforced, uncontrived chemistry. That being said, dancers should understand that *any* partners can learn to develop a trustful working relationship, whether they are married or unmarried, acquainted or unacquainted. Initially most dancers will find consistent rehearsal incredibly helpful. The more frequently partners work together, whether rehearsing specific choreography or experimenting with random exercises, the more casually the dancers will start to make discoveries about each other. Staying conscientiously sensitive and attuned to each other's needs, they will quickly grow to understand one another. Demonstrating reciprocal patience, humility, and professional respect will help them foster mutual confidence and sustain a trusting partnership.

There are various strategies dancers can use to persuade their partners subconsciously to place faith in them. A gentleman, for example, should assert himself with certainty when leading his partner, projecting his own security, confidence, and stability. Sensing his self-assurance typically enables a lady to feel safe, secure, and free to let go of worry or hesitancy. In turn, ladies can help gentlemen feel confident and capable by surrendering the "reins," though this can be extremely difficult to do voluntarily. More often than not, partnered dance, ballet in particular, celebrates chivalry. In fact, its overt gallantry is reminiscent of an era before the advent of modern feminism. Though choreographic demands in partnering *are* undoubtedly much higher on women in the twenty-first century, the lady must still allow her partner the control he will undoubtedly need to help her look and dance her best. In ballet, the gentleman does *not* typically lead in a conventional ballroom-dance fashion. Even so, he will still be predominantly in charge of "steering the ship." This does not mean, however, that the lady is free of obligation. A tremendous amount of work will be required of her as well. Most significantly she will be responsible for holding her trunk, better known as her "center," engaged and taut. This includes her innermost abdominal

core muscles, her upper back, her lumbar spine, and her lower pelvic region. She must achieve a delicate harmony, approaching the steps with centered control (as if unsupported) while being just relaxed enough to allow her partner the opportunity to maneuver and control her equilibrium as necessary. Hard though it may be, she must absolutely refrain from trying to take charge of the partnering herself.

Relinquishing control of the dance can be an unnerving concept for some dancers, particularly when two dancers learn and work at different paces. A lady's natural urge to make adjustments and self-partner will almost always surface in the early stages of a partnership. As the gentleman takes time to find his way, gradually discovering how best to partner her, the lady may find she has to negotiate some uncomfortable situations: falling off pointe and off balance, struggling to smoothly connect step sequences, and lagging behind the music to name a few. It is imperative that both dancers remain patient, keeping in mind this truth: the male dancer will often have a great deal more to decipher within each passage than his female counterpart. For each and every step, the gentleman must decide where his hands should be placed (with consideration for his partner's proportions), where his body should be positioned in relation to hers, and what precisely his feet should be doing. He will be obliged to learn his partner's choreography in addition to his own and will need to maintain a constant focus on her, remaining aware of her inclinations and instantly calculating where she could be at any given moment. He must discover, navigate, and work around her personal intricacies, accommodating himself to meet her individual needs, her physical specificities, her center of gravity, and even her personality. All things considered, it would behoove dancers, both male and female, to be as mindful, sensitive, tolerant, and cooperative with each other as possible.

As with most everything, there are definite exceptions to the general rule of male dominance in partnering. Take for example much of Twyla Tharp's choreography. A woman who has audaciously broken through the gender restraints and stereotypes herself, her work naturally reflects the ideas of independence and autonomy. Much of her

choreography requires the female dancer to demonstrate a strength equal to, if not surpassing, that of her male counterpart. In the Tharp works we have danced, the woman is often responsible for supporting her male partner's weight against her own and for mustering the strength to use his weight as an opposite and equal force by which to propel her own movements. At times, she may even be required to reverse roles entirely, partnering the man herself. In the final section of *Nine Sinatra Songs*, for example, one of the women is required to take the reins and *promenade* her partner. Though it may not sound particularly challenging, even the simplest of role reversals can end up being surprisingly difficult. There is rarely any complacency in Tharp's choreography. On the contrary, in her *pas de deux*, one almost always encounters a push to meet a pull: two opposite forces working equally both with and against each other. This parity between the dancers helps to create the grounded, almost weighted, feeling associated with much of Tharp's work. In such untraditional dance situations, it may be difficult for one or both dancers to confidently trust the woman's seemingly weaker physique to support the man's center of gravity and weight. Regardless, they should try to place their trust in the actual *physics* of partnering: for every action there is an equal and opposite reaction. As two dancers shift with equal and opposing force, offsetting each other's weight in just the right way, they will find they are able to counterbalance one another regardless of their differences in muscle mass and weight. Often this can be managed without great physical exertion and with very little physical risk to the dancers.

As Carlos and I have discovered personally, trust in one another and trust in ourselves is essential to a technically and artistically successful *pas de deux*. If either dancer allows personal insecurity to morph into fear, inconsistent performance can be the unhappy result. Any bonds of trust the partners have worked to build will prove virtually irrelevant. Diffidence impedes timing; reluctance impedes unity. The end result is a shaky performance and a missed opportunity for achieving artistic excellence. Key to trusting a partner—and one of partnering's biggest challenges—is learning to maintain unwavering

faith in oneself. If dancers do not learn to believe in their own capabilities and to have confidence in both their muscle memory and their ability to perform under pressure, then they are likely to find it very difficult to trust a partner.

While "narcissistic" may seem an unduly harsh term to describe dancers, we are definitely a self-involved breed. It may be because we scrutinize ourselves in the mirror for hours a day or because we are constantly judged on appearances. Being understandably consumed with striving to look and dance their best, dancers must summon tremendous strength of will to give themselves over to another person, to *share* control over circumstances. If two dancers can manage to discover a state of calm in doing so, however, they will enjoy an intensified security and an unparalleled freedom—both, paradoxically, as the result of *surrendering* to one another. In striving to achieve unyielding confidence, as a couple, the dancers must dance *for* and *with* each other, completely. This means not worrying about the mirror, the audience, or the ballet masters. It requires tuning out other people in the room and ignoring their thoughts and opinions for the duration of the dance. It calls for the dancers' acknowledgment and acceptance of their respective insecurities and their willingness to guide each other along the path to overcoming them. It demands escape from the chains of insecurity and awakening to a deeper consciousness that leads to beauty, the beauty of a fluent and captivating physical conversation. Complete commitment must be the equal pledge of each dancer, for better or worse. It is only from this figurative marriage, both to the *pas de deux* and to each other, that genuine and unconditional trust between two partners will grow, blossom, and thrive.

5

——

Familiarity, Connection, and Communication

Exploring manners, eye contact, breathing, musicality, and physical cues

Impressive partnering work is typically the product of a finely tuned relationship between two dancers who seem to share a natural, unforced bond—a unique chemistry, so to speak. Their connection will remain indissoluble and constant. Though they may be on opposite ends of the stage, the energy field between them will stay electrified. Their *pas de deux* will likely evolve like a gripping conversation, each dancer hanging onto the other's every "word."

While not all partners are immediately or inherently compatible, it is extremely important that *all dancers* remain open minded and willing to devise ways of working effectively with anyone. Occasionally a dancer may find him- or herself paired with someone disagreeable: someone, perhaps, who overwhelmingly projects insecurity or has irritating eccentricities. Maybe even someone with a contradictory work ethic. No matter the scenario, dancers in both proven and untried partnerships will have to negotiate diplomatically and cordially through unpleasant circumstances from time to time. Even partners intimately familiar with one another can be hobbled by emotional

hurdles. As at ease as we are with one another, for example, Carlos and I sometimes still struggle to agree or to connect on a constructive working level. Not often, but it happens.

We faced such a challenge as we prepared to dance one of our most cherished ballets, *Giselle*. The circumstances should have been utterly romantic, with Adolphe Adam's lush score enveloping Miami City Ballet's corner rehearsal studio and the rich southern sun pouring in through the perpendicular walls of windows. Yet ironically, instead of dancing, we stood motionless, angrily staring each other down. A fierce tension pierced the atmosphere like a dagger. We had danced the leading roles of Giselle and Albrecht together many times, yet we found ourselves at an impasse, with frustration getting the better of us. We were entirely out of sync that day. Everything just felt off, from the flow of our pantomime, to the timing of our steps. We were colliding both literally and figuratively. Rehearsing privately and left to our own devices, our tempers soon flared. We foolishly confronted each other unprotected and uncensored. The faint line between good humored honesty and blatant disrespect didn't just blur, it vanished completely.

Married or not, longtime professional partners often tend to expect perfection of each other. Not merely unrealistic, such expectations can lead to impatience, frustration, and disillusionment. Former Miami City Ballet principal dancers and current artistic directors of Gulf Shore Ballet, husband and wife team Iliana Lopez and Franklin Gamero danced together regularly for decades. "Because of our familiarity, we always expected much more of each other than we did of our other partners," explains Lopez. "But, since we did want to set an example in the company, we talked things out a lot when we had a bad day to ensure the next would be better."[1]

Carlos and I have looked up to Lopez and Gamero as role models for years and have tried to emulate their admirable patience and calm

1 Author interview with Iliana Lopez, September 5, 2014, Ft. Myers, Fla. All subsequent statements from Lopez and Gamero are taken from this interview.

with one another. Nevertheless we can still fall inadvertently into the dangerous trap of abusing the confidence we share. As necessary as honesty is, it tends to be most effective when filtered. Bluntly speaking one's mind without care or consideration of the consequences can prove destructive, albeit temporarily. The natural connection and chemistry that a couple shares easily can be jeopardized by boorish candidness.

In that particular *Giselle* rehearsal, we both lost control of ourselves as our "innocently" honest remarks became tainted with bitter arrogance. In hindsight, our interchange was utterly ridiculous. One quip after another, our bickering quickly escalated, and unlike Lopez and Gamero, the couple we so admired, we were proving to be a horrid example for anyone to follow. We rolled our eyes and clenched our jaws, and our heavy sighs gave way to muttered objections and irritated grunts. One unproductive hour later, we were fuming and frustrated. In hindsight, though we had wasted precious rehearsal time, we *did* learn an invaluable lesson. Honesty is imperative and discussion is crucial, but they must never come at the expense of respect. A pair's professionalism and humane regard for one another's feelings must never be forsaken. Sometimes it is not the actual words that sting but, rather, the tone of voice that hits a nerve. Regardless of any prior relationship, grievance, ill will, or personal issue that may exist behind the scenes, in the studio and on the stage dancers must recognize that their partners have taken on the roles of friend, ally, and savior. They deserve to be treated with unfaltering professionalism, respect, patience, and dignity. Always. Without question. Easier said than done, practicing tolerance and showing appreciation are imperative to healthy working relationships, whether two dancers are intimate, mere acquaintances, or strangers. In communicating freely, both dancers must be fully conscious of and sensitive to one another's feelings. Even the tiniest efforts made in the name of graciousness, humility, and respect can potentially go a long way toward building and maintaining a secure partnership.

When two dancers are sensitively attuned to each other, they can

communicate clearly without speech. Eventually, as partners build familiarity, they learn to converse through body language, breathing patterns, eye contact, and interpretations of musical nuance. In fact, whether language barriers, shyness, or hidden attraction were the reason, Carlos and I barely spoke during our first couple of years as dance partners. We managed to iron out difficulties by listening to each other's physical cues, making appropriate adjustments, and patiently repeating the steps after each modification. Eventually we built up the confidence to articulate our needs verbally, but we also quickly discovered that this generally was not the most effective choice for us given our temperaments—at least not *during* actual rehearsal time. While sadly it isn't always what we practice, we have found that when we discuss issues either before or after we get into the studio our rehearsals flow much more smoothly. When we are rested and disconnected from the stress of the studio, we are both much less hotheaded and hypersensitive. With less pressure, we can remain calm enough to actually *hear* each other out and process suggestions. The ability to communicate freely ultimately boils down to dancers accepting each other for the persons they are. Dancers must bear in mind that each individual has a distinct personality and way of working. Every now and then, less "talking" and more "doing" may prove to be the most productive means to a positive end. And since dancers are rarely granted the privilege of lengthy conversations during performance, at the very least, nonverbal communication can be a useful exercise, an opportunity to work on practical skills for the stage.

Utilize the Benefits of Eye Contact

Finding nonverbal means of communication can be especially valuable for partners who are not clearly compatible. By way of gaze alone, two dancers can effectively converse without speaking a word. Through direct eye contact with another person, one can easily interpret hesitancy and confidence and can even gauge intent. Locking

eyes creates a formidable bond between two dancers. The audience often perceives this intangible connection as something mysterious: as magnetism or chemistry.

Consistent eye contact helps Carlos and I stay in character when we need to and allows us to stay in tune with the countless inconsistencies encountered during a *pas de deux*. If one of us is having an "off" day or is completely absorbed in a moment, it will undoubtedly show in our eyes. By watching each other closely, we are able to remain coordinated should one of us move slightly ahead of or behind the music. This becomes especially important when dancing to the varying tempi of a live orchestra. We also rely on eye contact to convey emotional information to each other. By doing so, we are able to draw from and bolster each other's strength, energy, and stamina.

Learn to Interpret Physical Suggestion

Once the curtain rises, anything can happen. For dancers, the stage is generally not conducive to dialogue, and depending on the demands of the choreography, it's possible that a male dancer could dance most of a *pas de deux* staring at the back of his ballerina's chignon. In situations where opportunities for eye contact are limited, dancers can still communicate effectively through other physical cues: interpreting each other's shifts in weight, for example. Whether partners have enjoyed the luxury of abundant rehearsal time or have been paired at the very last minute, they must be constantly aware of one another's physical suggestions. Remaining alert, focused, and attentive facilitates conversation via body language, which can provide a veritable safety net should other methods fall short. With a simple squeeze of the hand, for example, a lady can signal her partner that she needs more support or let him know that she does not yet feel balanced securely enough to let go. If she abruptly leans into him or her weight shifts severely, he can be fairly certain that she is not centered (or "on her leg"). Suddenly feeling her weight quite heavily in his hands, he will know that he needs to adjust her balance. If the gentleman suddenly tightens *his* grip, whether around the lady's waist, wrists, or

hands, *she* may safely assume that he is having difficulty finding her center of gravity. She will then know to give him an extra moment to regain his control before moving on to the next step. Informative and invaluable physical suggestions like these can be expressed and interpreted instantaneously, as long as both dancers are committed to being actively alert and present in the moment.

Connect through Breathing

Keen awareness of breathing patterns can prove essential to a couple's connection. The way dancers breathe can positively or negatively impact their performance and, likewise, their partnering work. Still, dancers often fail to place sufficient importance on the deliberate timing of their inhalations and exhalations. Taking in and releasing deep breaths can help a dancer remain calm, centered, focused, and composed—all of which are fundamental to successful partnering. These breaths are most helpful, however, when properly timed. For example, by exhaling deeply as the gentleman initiates a lift, a lady misguidedly exerts an oppositional force to her partner's efforts. "Applying the correct breathing is crucial, *especially during lifts*," agrees Iliana Lopez. "The lady should be very conscious not to exhale right before she is to be lifted." By counteracting her partner's force, the lady will seem heavier and harder to lift, toss, or carry. In most fitness techniques, exhalation coincides with exertion or with the heaviest part of a movement. In contrast, by inhaling when she pushes off the ground for a lift and exhaling on the way down, a ballerina ensures that the momentum of her breath will match the impetus of the lift itself, *assisting* the gentleman in his efforts. Facilitating the action and producing a fluid effect, the lady will appear weightless in space, as if she were floating. The same technique proves true for *pirouettes*. If a lady exhales deeply while turning, she may inadvertently relax her midsection, making it difficult for her partner to maintain control of her balance. Instead, inhaling and pulling up while rotating should help her to hold her core and back strong. By exhaling only at the end of the *pirouette*—not by dropping the stomach, but by lifting it in and

up and drawing the ribs together—the lady enables the gentleman to better maintain control of her placement and center of gravity, especially as her momentum slows.

With his hands placed around the lady's abdomen during partnering, a gentleman can feel her breathing patterns quite easily. Random respiration (huffing, puffing, and panting) can interrupt the lines of communication, disrupt the timing of a movement, and throw off the rhythms of partnering. Certainly not every breath can be precisely controlled and exactly timed to the choreography. Coordinating *crucial* inhalations and exhalations with the phrasing of the steps, however, will unquestionably prove advantageous. It will help reduce sensations of weight, center the lady's balance, and provide the gentleman information about the lady's personal sense of musicality and interpretation. By effectively determining when his partner intends to begin and end a step, the gentleman can automatically produce appropriate and timely responses to the ballerina's actions.

It is also important that gentlemen be aware of their *own* breathing patterns. Theirs, however, should follow the more traditional respiratory pattern practiced while exercising: inhaling deeply just before a lift (on the bend-down) and exhaling upon exertion, as the ballerina is being raised.[2]

Bonding through Interpreting the Music

An extremely dependable way for partners to remain connected is through the music itself. Not just by listening to it, but by truly hearing and embodying it: feeling the music internally, dissecting it intellectually, and interpreting it emotionally. Argentine Tango dancers are a wonderful example of this idea. Conversing intimately through the musicality of the steps for the duration of the partnered dance, they remain deeply connected. While ballroom tango is choreographed,

2 Though the force male dancers must exert will often be great, they should still try to repress the urge to grunt and groan. Straining audibly, even if unintentional, can be unsettling for both the audience and the ballerina and, in turn, may negatively impact the couple's dancing.

making it decidedly less natural and more theatrically exaggerated, the Argentine Tango is spontaneous, gentle, intimate, and completely inspired by its music. The characteristics of traditional social dances, such as the Argentine Tango, are similar to those of *pas de deux* in that such dances are a collective synergy of body, mind, and spirit between two dancers on several intimate levels: emotional, physical, intellectual, and artistic. Its improvisational spontaneity and creativity, however, are entirely unlike the regulated framework of ballroom dance or the technical structure of ballet *pas de deux*. Mostly free of institutional rules and standards, social dancers follow a universal "foundation" rather than a strictly outlined "technique." Social dance also tends to be undiscriminating and multigenerational, including dancers of widely varying skill levels and experience. According to Monica Llobet, professionally renowned World Cup Argentine Tango champion and founder of Miami's well-known Alma de Tango events, tango dancers often rely on their cohesive interpretations of the music for structuring and maintaining the intensity of their connection: "With time, we start to become familiar with different tango orchestras and the characteristics of their music. We must develop a strong ear not only for the beat, but for what is going on between the beats and musical phrases. Like telling a tale, we need to treat each musical phrase and pause like lines in our story. When a couple has a strong foundation, and both partners hear the music together, the story becomes clear—much easier to follow and to dance."[3]

As with the Argentine tango, dancers will find that a couple's cohesive musicality is amazingly significant in the partnering work of most other dance genres as well. Dancers will surely benefit from listening to recordings of their music together, without dancing at first, to determine if their interpretations are indeed symbiotic. They might then try marking out the steps as they listen, discussing phrasing ideas, determining if and when to retard or to syncopate, and planning how best to approach each individual passage. The musicality of

3 Author interview with Monica Llobet, April 3, 2015, Miami, Fla. All subsequent Llobet statements are taken from this interview.

a *pas de deux* needs to be coordinated by the dancers as a team or else it will be muddled—like a constantly interrupted conversation between two people trying to communicate with one another. Having live orchestral accompaniment means that tempi will likely vary, feeling quick one day and then markedly slower the next. Such variations in speed will usually come without warning. It is imperative that both dancers familiarize themselves with their partner's musical inclinations and learn to read their rhythmic intentions (phrasing). For example, if the orchestra is playing quickly one night and a couple has agreed that the high point of a lift in *grand jété* (a throw or carry through the air as the lady holds a position resembling a split) should happen on a particular crescendo in the music, then the gentlemen will likely be prepared for the ballerina's automatic response to the speed. She may feel pressured to prepare with a smaller or quicker *glissade* (gliding preparation) than usual or to hurriedly approach the sequence leading into the preparation. While compensating for the lady's anticipation might tax the gentleman physically, agreeing upon their musical objectives beforehand will prevent him from being caught dangerously off guard.

Take Advantage of Insightful Acting

If even the friendliest of couples periodically find it difficult to communicate and connect, then do those who are paired with less-than-favorable partners have any real hope of finding or building a true connection? The answer is yes, absolutely. Without a doubt, partners may intermittently find they are not fond of each other on a personal level and on rare occasions may even find it hard to handle one another on a professional level. Should this be the case, the audience must remain unaware. Dramatics are as integral an aspect of the art of partnering as they are of the art of dance itself. When a natural connection between partners is lacking, a bit of pretending may be necessary. Simply stated, it is a dancer's duty to be impressively convincing. Whether one is assuming a particular character or the dance is entirely abstract, a dancer must credibly portray a role to the best

of his or her ability, upholding the integrity of the choreography regardless of any underlying apprehension, tension, or friction with a partner. The public is entitled to be presented with two dancers who are comfortable and confident with one another or at least appear to be, even if this is not the reality.

We certainly *do not* recommend that relationships be structured around dishonesty and insincerity. However, occasional and strategic "acting" skills may enhance one's powers of persuasion. It is entirely possible to finesse one's partner, even when irreconcilable differences abound. Placing frustrations aside and showing professional respect and appreciation for someone (contrived though it may be) will usually encourage cooperation from even the most averse personalities. Feigning admiration for one's partner (or affection as is often called for in choreography) can be downright difficult to bear in extreme circumstances. Still, it is a skill that merits cultivation. Trials and tribulations within a partnership can be approached as positives rather than negatives. Overcoming them can be a prime opportunity to mature as a partner and to advance artistically. Imagining a "preferable" partner, assuming an alternate persona, even inventing a storyline to follow when one is lacking: these are just a few strategies that may be worth trying. Eventually individual artists will discover which methods produce the least frustrating interactions and promote artistic productivity.[4]

Prioritize Teamwork

Attentiveness, sensitivity, and a couple's allegiance to their united effort ultimately combine as the most crucial foundation on which to build a steadfast connection. If these are prioritized, other elements of a solid partnership will automatically follow. Lopez and Gamero were each revered during their careers as great partners, regardless of

4 With the many built-in burdens and heavy demands of our profession, dancers will do well to "lighten up" a bit, taking themselves, their partners, and their work a little less than seriously every now and again. Learning to laugh at oneself helps a dancer discover the hidden humor in others and in frustrating situations.

whom they were paired with. They had an intangible intimacy and understanding of one another yet somehow managed to translate that same trust and comfort into their partnerships with other dancers as well. It always seemed that they were masters of partnering's most prized secrets. "In dance there really aren't any true 'secrets,'" they openly admit.

> Luckily, our individual approaches to dancing happened to be very similar, and for both of us the "pas de deux" was an integral part of each performance. If the "pas" went well, our state of mind was automatically more at ease. Everything from there on would then go smoothly too. We believe that if you work very hard, in a positive way, things will evolve for the better. As the saying goes, "practice makes perfect," and we have found this to be especially true in partnering. It is all about diligence, teamwork, selflessness, and aiming for what is best for the both of you. Two dancers must work together persistently to really succeed in making their partnering look flawless.

Carlos and I have found that communication ultimately benefits everyone, enhancing even the most imperfect partnerships, whether discreetly through musical interpretation and subtle physical cues or overtly through straightforward dialog. Dancers will find in their artistic progression that listening and comprehending are equally as important, if not more important, than suggesting and directing. This is a truth Monica Llobet recognizes in her experience dancing the Argentine Tango: "As we advance as dancers and partners" she says, "we learn not only to tell, but to listen, and thereby a beautiful dialog begins." That dialog is truly the heart of any *pas de deux*.

6

"Couples Counseling"

Managing the challenges of partnerships that reach beyond studio boundaries

As partners press up against one another, gaze into each other's eyes, breathe in the scent of each other, and even taste one another's perspiration, it is not at all uncommon for them to become mutually infatuated. In dance, passions run high, and sexual orientation has little to do with the deep emotional connection that often develops between partners. It is absolutely possible for homosexual dancers to have affections for their heterosexual dance partners and vice versa. In general, dance partnerships, especially those cultivated over time, can foster tremendous heart-felt and physical comfort. Therefore, *if* a special relationship begins to bud between two dancers, it may be involuntarily fed through the dance. *Pas de deux* work has the capacity to be terribly romantic, and in all honesty it is how Carlos' and my love affair blossomed.

Fixated on each other's eyes, smiling, and playfully nudging one another on the shoulder, butterflies were aflutter. We were rehearsing "One for My Baby, and One More for the Road," a playfully romantic *pas de deux* from Twyla Tharp's famous ballet *Nine Sinatra Songs*.[1]

1 Twyla Tharp continues to be one of America's finest and most widely recognized female choreographers. Her dances are best known for their creativity, relaxed sense of humor, technical complexity, athleticism and precision, and are usually flavored with her signature "streetwise nonchalance."

We were not yet dating, and actually, we had really just begun to discover the beginnings of a friendship outside of work. Still, there was no denying that an acute attraction between us definitely existed. Truthfully it always had; but it was starting to take on a life all its own.

Ms. Tharp was in Miami, coaching the company in the ballet herself. In front of such a powerful presence, we could barely contain our nerves. Carlos and I locked eyes and found our calm. We had always shared a secure bond through visual contact. When the rehearsal ended, Twyla gave some general notes, but the biggest criticism she offered was about "connection." It was, after all, a ballet themed on the various stages of romantic relationships. As we remember them, her comments went something like this: "Eye contact, people. You need to really look at each other." Then she playfully glanced our way. "Those two have it. Hmm. . . . Maybe they've got too much of it!" As she chuckled dryly, singling us out, we felt our cheeks turning warm, blushing with embarrassment. That was just the beginning. Over a decade, a marriage, and a toddler later, dancing together still serves as an outlet through which we romantically reconnect.

Attraction, close friendship, and even romance between dance partners can all be magnificent gifts, but they can also be curses. For such parings to succeed, both professionally and personally, partners must come to several understandings and remain conscientious of respecting certain boundaries. One of the most glorious experiences we have ever had dancing together as husband and wife was in John Cranko's *Romeo and Juliet*. A more perfect ballet to dance opposite one's real-life love simply doesn't exist. It is still hard to believe that because we *are* a couple, we were almost denied the opportunity to dance it together. Prior experience had prejudiced Reid Anderson, proprietor of the John Cranko Trust, against pairing married couples together. He felt they bickered too often, were quick to place blame, and typically held grudges. He had little tolerance for such nuisance behaviors and believed that this sort of comportment would hinder proper interpretation and portrayal of the characters. Our hearts sank at the thought of being separated for such a romantic ballet. Fortunately, and miraculously, Mr. Anderson agreed to give us a chance

together on a provisional basis. We were painfully aware that with one single outburst, or with the slightest public display of disagreement, we would be permanently separated for this ballet. As those who know us well would surely agree, we have never negotiated a greater professional challenge. In the weeks that followed, we mutually agreed to put into play our most cordial "acting" skills. Being *forced* to mind our manners in rehearsal turned out to be a huge benefit. It helped us to work far more proficiently than we had in a very long time, and it unexpectedly rekindled much of the professional chemistry and rapport we had shared prior to becoming romantically involved.

Natural chemistry, essential trust, and comfort communicating are all advantages specific to dancing with a familiar partner. That the person responsible for your well-being on stage arguably knows you better than you know yourself can be a tremendous psychological bonus, like a cozy security blanket. It is that same personal comfort, however, that can cause complication. Overabundant assurance can lead to carelessness and overwrought anticipation. For Carlos and me, it often causes us to make assumptions and premature corrections. Just as heightened intuition can be a useful tool, it can also hinder a couple's groundedness and ability to work effectively as a team.

One of partnering's ever-important challenges is acknowledging *actual* events *as* they occur. And then responding swiftly and appropriately to them. Preconceived suppositions and anticipated responses can inadvertently dilute the power, intensity, and spontaneity of a *pas de deux* and even cause accidents. Presumptions have little validity in partnering work and should be kept in check. This applies in any case, whether one is dancing with a familiar partner, a friend, or a spouse. A great partner will never take *anything* for granted, no matter with whom they are paired. Each and every dancer deserves their partner's undivided attention, cooperation, courtesy, and receptiveness. Dancers are all unique. Many will vary in consistency from day to day or from rehearsal to performance and for any number of reasons. At times, automatically presuming and predicting what

someone will need can even prove dangerous, as circumstances can change at any given moment, particularly during performances. In one particular performance of *The Nutcracker*, a bone in my right foot shifted out of place during a *promenade* at the end of the adagio. My foot was completely jammed, immobile, and unresponsive. There was no time to explain what was happening to Carlos. I made an immediate choice to omit the next step in the choreography, avoiding the use of my right foot. Carlos responded immediately to the change and we were out of sync for barely even a second. Had he not been attentively in tune with me, or had presumption prevented him from following my cues, I am certain that I would have been seriously injured.

Some lucky couples may find that they are indeed able to make accurate predictions while partnering. This may give them extra peace of mind. *Too much* safety, however, can take away the daring edge which makes a *pas de deux* exciting. Admittedly, knowing each other as well as Carlos and I do has led us to make premature adjustments, automatically attempting to correct missteps before they happen. In retrospect, we have come to realize that in many circumstances such advance modifications have actually thrown off our timing, placement, and coordination—and have ultimately proved very frustrating. Resisting the urge to precorrect will always be a challenge, but in learning from our mistakes, we try to remain conscientious and respond to each other in the moment, one step at a time. In general, this proves a much bolder, more courageous, and more successful way of partnering. Ultimately we have found that this approach allows for an even deeper connection, a more fulfilling experience, and a much richer partnership.

Observing common courtesy is another crucial element of successful partnering, which tends to be overlooked by "familiar" couples. Such courtesy includes being mindful of one's manners, tone of voice, and use of body language. Feeling frustrated and even annoyed with one another while working on a *pas de deux* is entirely understandable. And completely normal. Every pair of dancers is bound to encounter such feelings, whether they disguise them well or not.

What is positively *impermissible* under any circumstance, however, is for partners to show personal or professional disrespect for one another. Since sensitivities are usually heightened between two people who care for one another, couples must be mindful in choosing the words they exchange and must remember just how negatively personal criticism can be taken. They should also keep in mind that the nastiest insults are sometimes wielded with nary a word spoken. Dancers communicate incredibly effectively through movement, gesture, and facial expression. Because our feelings and thoughts are so easily interpreted through our body language, we must be particularly aware of our *physical* comments and reactions and the adverse impact they can have on our partners.

All potential pitfalls aside, familiar couples should NOT be afraid of, nor intimidated by working together. If mutual respect is present and manners are minded, the bond of trust that intimate couples typically share can lead to some of the loveliest, most sensual, masterful, and riveting of *pas de deux*. Partners must have both personal and professional faith in one another and relish their special connection. They should consistently take advantage of, and build upon, their natural chemistry. Drawing on the personal secrets they undoubtedly share and using them positively as tools for enhancing the intimacies and sensitivities within a dance, partners who are also close friends, kin, lovers, or spouses often have the power to develop unique dance partnerships possessing an intangible charm and incomparable allure. There is little in life sweeter for a dancer than sharing the richly fulfilling artistic experience that a *pas de deux* offers with someone you genuinely care for.

7

Practicing Proper Form

Techniques to help partners dance together safely and smoothly

Attention to technical detail will prove critical in many aspects of dance, and *pas de deux* work is no exception. Partnering with proper form is essential, and it will directly impact the physical and emotional security of both dancers: in executing lifts or any other more or less complicated movements.

At times, partners become so caught up in worrying about each other that they neglect to pay adequate attention to themselves. Each dancer, as an individual, must feel confident, steady, and secure. Only then can the partners project their stability and conviction into the team effort. Argentine tango champion and longtime instructor Monica Llobet suggests that this idea is true in the tango as well. "In the world of Argentine tango, there are several variables in play. We must start with the basic fundamental elements. Before we begin a movement, we must first develop an awareness of our own individual body alignment, and only then may we find our balance and alignment as a couple."[1] When two dancers feel secure in their own physical balance, they have more freedom to safely and actively participate in the partnered conversation.

1 Author interview with Monica Llobet, April 3, 2015, Miami, Fla.

Dancers often take action "in the moment," little considering the possible consequences. Amidst the excitement of being on stage, this spontaneity may well prove necessary. It is in exactly such instances, however, that accidents and injuries can happen. It is therefore crucial for dancers to have a strong, long-established technical base to draw from. Daily rehearsals and heavy performance schedules inevitably lead to overuse injuries, as well as to the body's gradual wear and tear. The more that dancers can train themselves to practice *correctly* and *efficiently* on a regular basis—minding the intricacies *within* the steps—the better off they will be later on.

Ladies

A lady can sometimes feel frustrated and helpless during *pas de deux* work, as if she were expected to dance at the mercy of her partner's whims. Placing physical technique aside, temporarily, there are several actions she can take to empower and help herself and, as a result, help her partner.

(1) Refrain from "Backseat Driving"

Dance etiquette remains terribly old fashioned in that the lady's fate typically lies in the hands of the chivalrous gentleman, both figuratively and literally. The female's role will indeed be very challenging, yet her efforts will usually remain invisible to the average spectator. The general public rarely realizes how much strength is required to hold a position while suspended in mid-air. Nor are they likely to fathom the tenacity it takes to overcome the nerves and apprehensions that typically accompany being lifted, tossed, and thrown. A female dancer must be extremely committed to the choreography and, even more significantly, to whole-heartedly trusting her partner. Undeniably her role in the *pas de deux* will require tremendous physical and mental resolve.

Though easier said than done, complete faith in her partner will benefit a female dancer, who will do best to surrender the reigns and resist the urge to self-adjust or "self-partner." When dancers battle for

control, they lose coordination and missteps and injuries are bound to happen. There can only be one true leader. While it is typically the male, this does not mean the lady is a simply a silent "follower." The female must actively participate in the dance and will sometimes be responsible for initiating both the action and momentum for certain steps. Nevertheless, it is most often the male who will take on the duty of "steering the ship," reserving the right to manipulate the circumstances. The lady can help her partner by giving him her weight confidently and purposefully, without making secondary adjustments. Responsible for maintaining a constant and delicate balance, she will need to keep her body contained and compact yet not rigid. She must remain supple and malleable enough for her partner to maneuver her while maintaining her solidity at all times. The entire success of a *pas de deux* may very well ride on her consent. Plainly stated, she must allow the gentleman to do his job. At first it may feel strange to the female dancer to be so passive, so submissive, but it will prove extremely advantageous, especially when she is paired with a truly competent partner. Surrendering control will ultimately provide her freedom and make complex, intricate partnering much more enjoyable, less strenuous, and far less intimidating.

(2) Physical Awareness and Conditioning

Cross-training can significantly supplement a female's *pas de deux* work, helping her to build trunk strength, shoulder stability, power in the legs, and overall stamina. A solid abdominal core helps protect the lady against back injury, a common risk associated with being manipulated, tossed, and caught in compromising positions. It will also help her keep herself contained in the event that her partner throws her off, which unquestionably happens with even the best partners. A female dancer should have enough strength in her mid-section to sustain control of her own balance without having to rely solely on her partner's support for stability. While the gentleman's job is to assist his partner, she should be capable of executing the steps as if she were on her own, without collapsing.

Building shoulder girdle stability is also terrifically important, and

especially useful for negotiating tricky *promenades*, off-balance leans, and movements that call for counterbalanced stances and grips. Weakness or hypermobility in the shoulder girdle will put a dancer at risk of strains and tears in the ligaments and tendons of the rotator cuff as well as in the muscles surrounding it. Depending on the movement and the amount of stress placed on the joint, dislocation is also a danger. To avoid the likelihood of such injuries, abdominal and shoulder girdle strength should be built up and maintained by following a regimen of exercises tailored to suit a female dancer's unique needs. (See appendix for sample exercises.)

(3) Trust Yourself, and Go For It!

There is no room for tentativeness in partnering. Both dancers should try to execute the steps "full out," unless they have previously agreed to do otherwise. Approaching passages confidently and executing them clearly will allow a lady's partner to more easily read her movements and interpret her intentions. If the gentleman can visually establish exactly *what* his partner is doing, *how* she is approaching, and *where* she intends to step, he can more accurately plan his response to her movements and better accommodate himself to her needs. Not only is a "go for broke" approach exciting because it is immediate and confident, but it is also straightforward, which should ultimately help both partners feel stable and secure.

Because in *pas de deux* work, the gentleman often assists the lady in the same way a ballet *barre* does, she should rely on him in exactly that manner. If she puts too much weight on him during *promenades*, for example, he will find it very difficult to decipher where her center of gravity is and, therefore, where her balance should be. She will immediately become heavier and harder to maneuver. Using an actual *barre* for practice (portable ones work best), a lady can experiment to determine exactly how much weight she can safely place on the gentleman's hands or shoulders. If the *barre* tips over, off its balance, the dancer will know immediately that she is leaning into it (and likely into her partner) too heavily and aggressively and that a lighter, gentler approach will serve her better.

(4) Keep Calm and Partner On

As frightening as some overhead lifts and tosses may be for the female dancer, she must refrain from abandoning her responsibilities to her partner and herself by nervously laughing, screaming, relaxing, collapsing, hesitating, or breaking a pose. The consequences of any and all such actions are potentially dangerous. If a dancer feels especially wary of a certain lift, the couple will be wise to have one or two spotters standing nearby, ready to quickly step in and assist should something go wrong. Partners may want to continue practicing with spotters until both feel confident enough to execute the lift on their own. If confidence is slow to come, a swimming pool can be a relatively safe place for partners to work out the details of intimidating overhead lifts: the risks associated with being dropped will be significantly diminished there. As another option, strategically padding a small area of studio floor with foam gymnasium mats can help to cushion possible falls, giving both dancers added peace of mind.

In a futile attempt to save herself during an off-balance *promenade,* a lady will often resort to overenthusiastically squeezing her partner's hand or tugging his arm. These instinctive responses may seem sensible in the moment, but the lady needs to be aware that such actions will seriously hinder the gentleman's partnering abilities. Ladies must remember that in *pas de deux* work it is the gentleman's job to keep control of and fix a problem situation. Excessive gripping, squeezing, tugging, or pushing can prevent him from doing exactly that. An attentive partner will likely be aware of the lady's discomfort and will try his best to find her center and help her regain balance. By creating excess tension, she will actually prevent his making the necessary inferences and adjustments. By struggling inadvertently against her partner's effort, the lady will make herself difficult to maneuver. Also a safety hazard, clutching and gripping actions can lead to sprained or broken fingers, especially during finger *pirouettes.* By keeping a firm shoulder and wrist while maintaining a light-handed grip, the lady will help the gentleman feel and find where the balance may be off, allowing him the leeway he needs to adjust.

(5) Pull Yourself Together

It is a lady's responsibility to facilitate partnering work for her gentleman to the best of her ability. First and foremost, she must hold herself together, keeping her back and abdominals strong and stable so that she can easily be manipulated as one compact package. The positive impact this can have on the gentleman's labors is highly significant. Though the following analogy may seem silly, it is actually quite apt. Consider how much easier it is to toss and catch a taut, uncooked stick of spaghetti into the air versus a limp, overcooked noodle. The longer the dancer's limbs, the more challenging maintaining control of her body can be. Each person's center of gravity is different, but long-legged ladies tend to be "bottom heavy," meaning that their center of gravity will probably be down by their hips rather than up by the waist. This can make certain kinds of lifts (and other steps) hard on the gentleman. He may need to bend down farther before a lift to grab her just above the hips or place his hands lower down on her waist than typically would be comfortable for him during *promenades* and *pirouettes*. If his grip is too high, she will have a hard time controlling her lower half and will feel uncomfortable, as if she were dangling. The tighter the lady is able to hold her core together in any instance, the better chance her partner will have to accommodate himself to her specific needs, and appropriately distribute her weight in his grasp.

(6) The Eyes Have It

Female dancers may not realize how much visual focus can impact shifts in their balance. Focusing too high during *promenades* and *pirouettes* can throw a lady's weight awkwardly backward. Focusing too low may cause her weight to fall dangerously forward. The lady needs to concentrate her gaze straight ahead to stay most steadily *en balance*. When being lifted, a lady should aim her gaze upward to where the lift is taking her, and she should not to look down while being held up in the air. Shifting her focus groundward can cause abrupt shifts in her weight. It is these sudden deviations which increase the

probability of accidents and unnecessary injuries to the gentleman's shoulders and back. No matter the step, passage, or sequence, a dancer's most effective approach is usually to allow his or her gaze to follow the course of the movement naturally and organically, without letting anticipation, anxiety, or fear guide its direction.

Additional Tips to Remember

- Keep elbows down and in during *pirouettes*, and be constantly mindful of the gentleman's eyes, nose, and chin. Elbows can turn into weapons, causing black eyes and broken noses.
- To prevent pain and embarrassment, be aware of where all *arabesques* are directed. The location of the delicate "masculine area" makes it a bona fide bullseye for stray knees and legs.
- Be sure to provide the gentleman adequate weight to work with for lifts, leaning into his grip with control. Rather than "jumping" on the takeoff, push off the ground firmly, but gently. This will help your partner ride the lift's natural upward momentum and contribute to its looking effortless and weightless.
- Refrain from popping up from the bend of the knees in a *plié*, before taking off for any step, and avoid rushing at all costs. Give your partner the time he needs to firmly secure his grip and feel your timing.
- Provide a "shelf" for the gentleman's hand. Arching your upper back in a *cambré* while in the air will help him stabilize and carry the lift. Arching prematurely, however, will impede his efforts. Concentrate first on going straight up, matching the trajectory pattern of the lift, and then arch backward to rest on his hands just before reaching the lift's peak.
- Keep the shoulders square and locked during *promenades*, and consciously pull up and out of the supporting side. Sinking or leaning will make it difficult for you to maintain balance and keep your shoulders stabilized. For maintaining focus and balance during standard *promenades* in *first arabesque*, we

recommend looking into the gentleman's eyes or at his breast-bone while keeping your chest square to his chest.[2]

- During finger *pirouettes*, never squeeze or yank a gentleman's fingers. They can be easily sprained or broken. If you fear that the turn is veering off center, simply press upward into the gentleman's hand. He will read this signal and should be able to recenter and stabilize the turn or stop it safely and smoothly. Squeezing the gentleman's fingers painfully may prompt him to instinctively retract them. This can be dangerous for both dancers. Also do him the courtesy of selecting the finger he prefers to use, as individual preferences vary.

Gentlemen

Remarkably, what distinguishes a male dancer as a "great partner" has little to do with might and muscle. A truly gifted male partner exhibits his strength invisibly and enhances it with coordination, attentiveness, and keen precision in physical and musical timing. This skillful combination will make his labor appear effortless, seamless, and fluid.

(1) Organize Your Efforts

Because of the high demands placed upon them, male dancers tend to be at higher risk for injury than ballerinas, especially in partnering. Avoiding shoulder, neck, and back trauma is paramount for males in *pas de deux* work. Though frequenting a gym to develop upper body strength can certainly be worthwhile, body-building should not be a male dancer's primary focus. Instead, his learning to use the whole of his body's organization to facilitate partnering work (especially during lifts) is of equal or even greater importance than strength training. For example: making a deep or "juicy" bend of the knees (*plié*) before lifting will help produce the momentum needed to hoist a lady

2 Should eye-to-eye contact cause either partner dizziness, the lady's focusing on the gentleman's upper chest or collar bone will work as well.

up into the air. (This is akin to a weightlifter squatting deeply in preparation to lift a set of barbells.) Neglecting purposeful use of the legs increases both the overall difficulty of the task and the likelihood of severe injury to the shoulders and back. (Unfortunately, Carlos can speak from experience on this point. He has suffered both a severe rotator cuff tear and a minor fracture to his L5 disc. These injuries occurred separately, at different points in his career. Both might have been avoided had he focused more on using the power in his legs to help him when he was feeling overworked and fatigued.)

Maintaining proper form is extremely important for a male dancer. Doing so will help increase his physical strength and help him avoid injury. Resisting the natural urge to arch backward during overhead lifts, a male dancer *must* hold his core tightly engaged throughout the entire *pas de deux*. Though he will often need to shift his focus upward while lifting to keep an eye on his partner, he should do so only by tilting his head and neck slightly, not by arching in the back. Allowing the lower back to buckle will put tremendous pressure and strain on the delicate vertebrae, which can result in a fracture, tear, or herniation.

(2) Condition Productively and Intuitively

Since coordination and timing are integral to successful partnering, male dancers should try to incorporate both into an otherwise ordinary strength training routine, enhancing it constructively and intelligently to meet their needs *as* dancers. Weight-lifting exercises can be productively structured to mimic the physical patterns a male dancer would actually follow in lifting a partner. By using weights in place of his partner, he can practice the sequencing of his feet, the timing of the actual lift, and work on maintaining proper visual focus and concentration. Free of the stress that accompanies attending to a live partner, he may seize the opportunity to calmly and safely zero in on his own needs and responsibilities.[3] Practicing weight lifting and

3 For safety's sake, the dumbbells should weigh significantly less than a female dancer and be about half the weight the male dancer is capable of lifting.

weight bearing in a context directly related to partnering will develop a dancer's understanding of how best to use the strength he builds to his own and his partner's advantage.[4] (See chapter 14 for sample exercises.)

(3) Be Realistic

Though it is a fact of dance that the man is usually the one expected to take the reins and "fix" a problematic situation in performance, he should not feel pressured to act like a superhero in rehearsals. Constantly trying to remedy situations on one's own can prove impossibly frustrating for both partners. In addition, he should not feel responsible for every little thing that goes awry. (A chivalrous position, but not necessarily a productive one.) A gentleman should be able to clearly communicate to his partner his goals and intentions for the *pas de deux*, what he needs from her to help make them a reality, and what he thinks she may be able to do (or stop doing) to make his job easier and the outcome more successful. He must also, however, be ready to listen, acknowledging, accepting, and incorporating *her* feedback. He must willingly take his ballerina's feelings into equal consideration. Contrary to popular belief, mishaps are not "always the man's fault"—at least not in our experience. As the saying goes, "It takes two to tango" . . . and, most certainly, to partner.

(4) Know and Control Your Own Strength

The gentleman's utmost responsibility, of course, is to keep his lady safe from faltering and falling. But he must also be very careful not to accidentally injure her himself. An exceedingly firm grip, for example, or partnering her too high up on the torso can bruise her or, worse, crack her ribs. If a female suffers any partner-inflicted contusions while dancing a *pas de deux*, we need to ask whether the ends justify the means. A surefire way for the man to avoid causing harm is to press a large, flat, open palm—as opposed to a small, cupped

4 While male dancers may focus on conditioning their cores and upper bodies, they must not overlook building the back strength essential to increasing stability and to protecting the spine from herniated discs and fractures.

hand—securely against the lady's body. The thumb and forefinger should help the gentleman steer a lady's balance during a *promenade*, and all the fingers should be spread open to help assist with weight distribution during lifts and drags. The stress of weight bearing should be received and centered mainly in the palm, not delegated to the weaker, more flexible fingers. Should the fingers be forced to bear more weight than they can handle, a gentleman's first instinct will be to squeeze them into the lady to avoid losing his grip. Such squeezing is not only generally ineffective in partnering but also quite painful for the lady. While gently spreading the fingers evenly apart, the man should keep his palm just flat enough to remain concave but not cupped. By optimizing the broad surface area of his hand this way, he will be best able to maintain control of the lady's weight and balance, without causing her discomfort. An added bonus, this method will go a long way to mitigating arm, shoulder, and back strain, because the man will have the extended hand surface over which to distribute the lady's weight evenly.

(5) Be Aware

Keep a constant and keen eye on the alignment of the lady's shoulders, spine, and the crown of her head. This alignment is a constant indicator of where her balance lies in space. If her arms are up, they should generally be centered directly over her head (unless otherwise specified in the choreography): neither too far forward, nor too far backward. Such alignment is paramount for executing multiple finger *pirouettes*. The gentleman is responsible for keeping his finger pointed downward just over the center of the lady's head, which, depending on their difference in size, may mean that he will have to reach over and above her just a bit. Allowing her grip to veer off of the center of her body and in toward him as she rotates will pull the lady backward off her balance and make it hard for her to turn smoothly for more than just a couple of rotations.

In any variety of forms, imprecise placement of a lady's arms will usually cause her weight to shift awkwardly and make her feel heavy and off balance to the gentleman. Properly aligning her shoulders

vertically above her hips will help her to center her balance and stay "on her leg." During partnered *pirouettes* the gentleman should generally aim for keeping his chest horizontally square with the lady's spine. Maintaining visual focus on her waist will also help him to control any deviations in her weight or balance.

With time, practice, and experience, gentlemen will be able to rely less on visual focus alone and more on sensation. They will begin to *feel* where the lady's center of balance is without having to stare continually at her waist and legs. In fact, the development of such heightened intuition is imperative to successful ballet partnering as a lady's lower half will frequently be concealed from the gentleman's line of sight by her tutu.

(6) Placement Matters

By positioning his hands low down on the lady's waist, just above her hips, before a lift (while bending his knees down in *plié* simultaneously) the man will gain sufficient leeway when his grasp inevitably slides upward. Mistakenly arranging his hands at her natural waist almost always results in their sliding too high up on her ribcage as he lifts her, where they typically and awkwardly end up closer to her underarms than to her waist. This will prove both disturbing and unpleasant for the lady. It can also be risky as her delicate ribs are susceptible to injury in this position. Attempting lifts from a lady's upper waist is a common and costly mistake among male partners. A lady's center of gravity is never located as high up as the upper waist or ribcage, and trying to lift her from there will make her look (and feel) gawky. She will typically end up stranded clumsily in mid-air, with raised shoulders and dangling legs. Be forewarned, too, that partnering this way will almost guarantee that the gentleman loses control of a lift's descent—that is, should he succeed in getting the lady up to the full height of the lift at all. By grasping her lower waist (or lower back depending on the step) to initiate the lift, the gentleman will help his lady maintain control of her pelvis, legs, and core and will consequently make the work less taxing for both partners.

Additional Tips to Remember

- Don't be afraid to be gently assertive in leading the lady. She needs to physically feel your cues to know that you are confident and in control of the situation. Hesitancy on the man's part sends mixed signals, and figuring out how to respond to them can be confusing and nerve-wracking to the ballerina.
- The best male partners are invisible ones. The less apparent the man's work is to the audience the better.
- Always take full advantage of the power in your legs when attempting to lift. Tired though you may be, skimping on the *plié* preparation before a lift will make the lady's weight much harder to manage and will increase the vulnerability of your back and shoulders.
- Remember that "safe" can sometimes equal "boring." Taking a certain amount of intelligently calculated risk in partnering is necessary to the art of *pas de deux* and will force both partners to remain alert and focused at all times. The results can also prove exciting for the audience. Just be sure that you and your partner are in agreement as to where and when these risks will be taken so that neither of you is caught dangerously off guard.
- Always warm up sufficiently before attempting partnering work. Muscle spasms and other more serious injuries can be unpredictably triggered by even the simplest steps when the body is unprepared to instantaneously respond to the demands created by the motions of partnering.
- Think of the lady as an extension of yourself. If you feel unstable or uncomfortable, she probably feels the same way. Wherever you are the most grounded is where you will be able to meet her needs most successfully. You must first secure your own stance before you can care for your partner. As an example, consider the safety guidelines for using oxygen masks on airplanes: the stewardess always announces that you should assist the person next to you only once your own mask is securely fastened. Rushing to help someone else when your own safety is uncertain will lead you unintentionally to compromise their safety as

well. If you need an extra moment to adequately prepare before executing a particular step, clearly communicate your preference to the lady.

- Many gentlemen find that rubbing rosin on their hands prior to partnering helps to keep them from slipping, especially if the lady is wearing a shiny Lycra™ or nylon fabric or has sweat-soaked skin. Just be careful not to overdo it. Too much tackiness and friction can be equally uncomfortable and sometimes even dangerous (during finger *pirouettes*, for example). When possible, especially if rehearsing in practice clothes, rub rosin only on crucial areas, such as the lady's waist and back, and brush the excess off of your hands.

- Quite often in a *pas de deux*, gentlemen are not limited to standing in textbook ballet positions. Assuming more comfortable and stable stances allows you to support, steady, center, lift, and turn your partner with greater composure and finesse. Unless the choreography specifically calls for it, do not attempt to partner with your feet or heels glued together in first or fifth position. These stances will prove unstable, making discreet adjustments—should the lady falter or need immediate assistance—difficult to manage. A comfortable *demi-seconde* position with either a *pointed* or *demi-pointed tendu à la seconde* is an appropriate and recommended choice whenever possible. Depending on the circumstances, positioning the feet in a comfortably open *demi-seconde* stance will provide stability and will also allow the gentleman to disguise any corrections.

While these guidelines may seem overwhelming at first, rest assured that they will become second nature over time. Routine partnering practice will soon transform them into good habits permanently engrained in your mind and body. In the words of Anna Pavlova, the most famous Russian prima ballerina of the late nineteenth and early twentieth centuries, "master technique and then forget about it and be natural." Diligent work in the studio builds

the strength and confidence requisite to "let loose" on stage. Solid technique will always give dancers freedom to move, room to express themselves, and opportunity to both create and savor the moment.

8

Same-Sex Partnering

The beauties and challenges of same-sex dance partnerships

One of the greatest advances in the evolution of *pas de deux* has been the exploration of same-sex partnering work. Making particular headway in many contemporary ballet and modern dance works, the concept is really not as innovative as one might think. In the early nineteenth century for instance, French ballerina Fanny Elssler, illustrious rival of the famous Maria Taglioni, was often partnered by her sister in lieu of a man. Probably due to the popularity of their example, the casting of male dancers in France actually dwindled for a considerable period of time. In the first staging of the classic ballet *Coppelia* in France around 1870, the principal male role of Franz was both choreographed for and premiered by a woman, and it continued to be danced that way even after men regained their rightful positions in the French dance community.[1]

Audiences today encounter same sex partnering fairly often across dance genres, especially in contemporary ballet and modern dance. Though sexual preference and orientation rarely impact casting or choreography, society's ongoing struggle to accept homosexuality

1 *Ballet History 1440*, chapter 11, Department of Ballet, University of Utah (www. ballet.utah.edu/ballet4410/chapter11.html) .

sometimes influences the regard of same-sex dance partnerships as "peculiar." Social controversy aside, most dance aficionados will likely agree that from a purely physical perspective, same-sex partnering work can be impressive to behold. It generally requires tremendous focus, strength, and control (both mental and physical) for dancers of the same sex to masterfully navigate the challenges of partnering one another. Someone unfamiliar with dance might take for example the popular circus act involving two males or two females precariously balancing each other's weight while slowly transitioning through gravity-defying positions. The exhibition of such physical intensity can be breathtaking, even mind-boggling, to behold.

In contrast to the guidelines of traditional *pas de deux* work, same-sex partnerships most often call for equal give and take when it comes to force, balance, and power. While some dancers will easily adapt to these equalities, others may find the adjustment taxing. Either way, this type of work is interesting for dancers to explore, especially as a platform for discovering new dimensions of physical and mental control.

Whether a pair is male or female, both individual dancers will benefit equally in relying on proper partnering techniques as a strong foundation for their work (see chapter 7, "Practicing Proper Form"). Paired with a male, a female dancer is generally *not* expected to lift, carry, or balance her partner nor to bear any significant weight. In a female-to-female partnership on the other hand, both dancers will surely find themselves with a newfound responsibility: lifting or, at the very least, supporting, someone of a size and weight comparable to their own. Considerable adjustments will be necessary to facilitate the work of both the "lifter" and the "liftee." It can be unnerving, at least initially, to have to rely on (or be responsible for) another female, especially for classical ballet dancers. I was in my early twenties the first time I partnered with another female, dancing Jimmy Gamonet de los Heros' "Purple Bend I," a riveting and emotionally weighty *pas de deux* set to Barber's famous *Adagio for Strings*. As the first of two versions consisting of virtually identical choreography, it was originally imagined for two women and later translated for two

men. I was incredibly intimidated at first by the difficultly of adjusting to partnering another female, and the idea of being manipulated by one made me equally nervous. I was matched with one of the company's loveliest dancers, and she was notably taller than I. She also seemed just as muscularly dense as she was thin. I was responsible for steadily upholding and counterbalancing her body weight against my own. If I wobbled, shook, or buckled in any way, we would both topple. To stay stable, I relied primarily on mental focus, maintaining a deep, almost meditative, level of concentration. I learned to center myself by tightening my inner core muscles and to ground myself with a deep *plié*, driving my legs and feet down into the gravitational pull of the floor. Thankfully my partner was a constant pillar of strength and exceedingly focused. Working together in a spirit of generosity, we soon adapted to the idea of using our own weights, our lower abdomens, and our legs to lift and support ourselves while simultaneously bearing each other's weight. We learned to "listen" to each other's movements and impulses and to discern when it was appropriate to give and when it was safe to take. When we finally reached the time to perform, we reaped the benefits of our work. We felt calm and confident, free to immerse ourselves in the music and ride the emotional current of the choreography. Iliana Lopez, former prima ballerina assoluta of Miami City Ballet danced "Purple Bend I" many times as well, confessing that "it was a different world learning how to promenade a woman . . . and I certainly gained much more respect for male dancers after I tried lifting. It took me a substantial amount of time to discover which muscles I needed to use, and how to apply the proper timing."[2] Consistent rehearsal allowed her to find a beautiful synergy with her partner, and I so looked forward to watching them perform the piece, in awe of their unwaveringly harmonious connection with each other. Their impeccable timing, keen focus, and obvious understanding of each other's needs made their work a fantastic example to emulate.

2 Author interview with Iliana Lopez, September 5, 2014, Ft. Myers, Fla. All subsequent Lopez statements come from this interview.

Most often, a *pas de deux* choreographed for two women will not call for exceptionally complex lifting. Quite frankly, the partnering potential of two female dancers is confined at times by certain natural physical limitations specific to both the couple and the circumstances. Ladies are rarely asked to perform high overhead lifts, tosses, or catching sequences with each other in choreography. It is more likely that their partnering work will include counterbalancing and promenading. Lifts will generally be controlled, kept low to the ground, and stationary. Bolstering one's upper body strength through conditioning will provide peace of mind and add to one's sense of security, but it is certainly not necessary to go to extremes. Diligent rehearsal and patient, clear communication will usually enable two female dancers to discover *together* how best to counterbalance, resist, and assist each other. They will learn how to draw upon their own strengths while simultaneously feeding off of, and into, each other's, making the seemingly impossible task of taking on each other's weight possible.

Though female duets, in fluidity and nuance, can be particularly beautiful and inspiring, a *pas de deux* involving two men usually lends itself to a wider range of choreographic possibilities, at least acrobatically. Men's amplified power, strength, and capacity to bear weight and sustain it within movement allows for the repeated formation of controlled shapes in space. Remarkably, as magnified as the physical capacity and strength of two males can be, so too can be their emotional ferocity. Male partners' discovery of delicacy and grace in the balancing of physical with emotional force gives many male-on-male *pas de deux* a mystery and intensity that often exceeds that achieved by female partners.

When approaching same-sex partnering work for the first time, dancers need to understand that it will often require of them more patience, more rehearsal time, and more cooperation than is required of male-female partnerships. Both dancers must be willing to compromise, communicate, and accommodate. Since the end of her performing career, Lopez has worked frequently as a ballet master for Les Ballets Trockadero de Monte Carlo, an all-male company

which dances parodies of the classic ballets. She reveals that though the dancers disguise it well, the male-on-male partnering work they execute is far from easy. The partners, she explains, "constantly have to deal with the issue of greater weight-bearing responsibility, which can be exhausting, and they must also adjust to the fact that a man's back and hips are much wider and sometimes harder to manage than a woman's. Lifts, which are particularly challenging for them to master, will usually require two additional men entering the scene to offer help."

Patrick Corbin, renowned dancer with the Paul Taylor Company and a respected *repetiteur* of Taylor's works, has long experience dancing and staging male-on-male duets. Taylor choreographed over thirty dances during Corbin's fifteen-year tenure with the world-famous modern dance company, and many of these dances, actually choreographed on Corbin, contain a great deal of partnering. Explaining the signal differences between male-on-male and male-on-female partnering, Corbin remarks, "Almost always, when partnering a woman I was just trying to create a safe space for her to explore the extremes of her own technique. In partnering with another man, however, we were usually experimenting with how far weight sharing could take us both off balance, and what kind of lateral equilibrium we could attain."[3] As a *repetiteur* Corbin has staged Taylor's sensual homage to the tango, *Piazzola Caldera*, numerous times, and he agrees that the intriguing male duet in the second section attains an "amazing level of male-male partnering, not only in regard to the level of strength required, but also in the amount of sensitivity needed to accomplish several seemingly impossible tasks—particularly the moment when one man hinges down to his shoulders from a straight standing position while holding the other man upside down in the air. What a physical feat!"

Though modest in frame and stature, veteran Miami City Ballet principal soloist Didier Bramaz is often required to tackle male-

3 Author interview with Patrick Corbin, November 8, 2014, Miami, Fla. All subsequent Corbin statements come from this interview.

on-male partnering in the many ballets comprising the company's repertoire. His serene disposition, diligence, and innate sense of control have made these partnering experiences remarkably successful. Bramaz has found that being a heterosexual has made it significantly harder for him to acquiesce to the intimacies of partnering with other males. Despite the challenge to connect emotionally with his partner, he does reveal that "men actually tend to have more patience with one another, so it is sometimes easier to handle a man's personality and moods than it is a woman's—at least on a working level."[4] He has found that "since guys are much heavier, and they aren't often partnered, they usually don't know how to help, at least initially. Mastering a *pas de deux* definitely requires a lot of patience and teamwork." Having performed the *Piazzolla Caldera* duet numerous times and having worked on it with Corbin as *repetiteur*, Bramaz suggests that the "hinge did require a great deal of physical strength, but more importantly, I felt that it called for intense control and steady balance. I had to completely trust that my partner's feet would hit the ground before my back. Learning to really have faith in the movement so I could make a strong commitment to it was difficult, but it ultimately helped things flow much more safely and smoothly."

When it comes to same-sex partnering, the best bit of advice we can give is one which Corbin regularly extends to the dancers he works with: "Let yourself go. Good partnering is really about falling in love with your partner: it makes no difference if you are 'gay' or 'straight,' or if [the partner is] male or female. It is simply about connecting with another human being on a very intimate and beautiful level [through the dance]. Let love and respect flow and you'll surely have a great experience."

4 Author interview with Didier Bramaz, January 18, 2015, Miami, Fla. All subsequent Bramaz statements come from this interview.

9

Exemplary Partnerships
throughout History

Acknowledging a few of our greatest inspirations

In any performance art, there is much to be learned and gained by watching others. While it is wonderful to look to current dancers for inspiration, it is equally important to look back in ballet's past. The formidable partnerships that punctuate dance history will always be relevant to contemporary dance, even with the rapid advances that *pas de deux* work is striving to make. Individual dancers will naturally have their own particular tastes and will identify with distinctive artists to find enlightenment and motivation accordingly. With that in mind, we turn in this chapter to some of the timeless couples we find personally inspiring. They are among the pairs we most admire and whose work we still strive to emulate as we try to become better dancers, partners, and artists.

Rudolph Nureyev and Margot Fonteyn

Though Nureyev was almost twenty years Fonteyn's junior, these ballet superstars complemented each other nearly perfectly, sharing a

unique rapport and camaraderie. Their chemistry was so dynamic, in fact, that they danced almost as if they were a single entity onstage, leading many to speculate that they were involved romantically. (He was primarily homosexual, and she was married to a prominent ambassador.) Regardless of whether these speculations are true or false, an undeniable electricity crackled between the two of them as they danced. His fiery Soviet boldness perfectly amplified her demure, refined British elegance, and his youthful boldness was balanced by her mature artistic intelligence. Their harmony translated powerfully to the audience, and they shared an intensity of natural passion that is nearly unmatched by any other dance partners in history.

Mikhail Baryshnikov and Gelsey Kirkland

The Baryshnikov-Kirkland partnership is indisputably one of the most famous in American ballet. It is hard to think of two other dancers who so excelled as true equals in both technical and artistic brilliance, whether dancing alone or as partners. Destiny brought them together in 1972 when Kirkland toured Russia with New York City Ballet. When Baryshnikov defected to the United States a couple of years later, he immediately asked Kirkland to join the American Ballet Theater with him as his partner. They famously partnered in several ballets throughout their concurrent careers with ABT: their interpretations of *Giselle, Romeo and Juliet, The Nutcracker* (Baryshnikov's own version), Jerome Robbins' *Other Dances*, and George Balanchine's *Theme and Variations* are among their memorable performances that first come to mind. They simultaneously complemented and juxtaposed each other's distinctive strengths, and they seemed to share a special understanding and respect for each other's artistic and stylistic trademarks. Following Kirkland's 1981 return to the stage after battling drug addiction, anorexia, and several other health issues, Anna Kisselgoff, in a glowing review for the *New York Times*, perfectly described the duet's performance of Jerome Robbins' *Other Dances*: "While his phrasing was sharp and impetuous,

Kirkland responded with dancing that was an elongated sigh." Kisselgoff also noted "the special attention [that] Mr. Baryshnikov gave his partner" and "the way he adjusted his dancing to [hers]." Without a doubt "the growth of compatibility during the course of the performance" was one of its "marked beauties."[1] Baryshnikov and Kirkland shared a unique compatibility and camaraderie and made every step they danced together look seamless and effortless.

Peter Martins and Suzanne Farrell

This legendary dance couple was impeccably matched in their physiques. With his smooth, clean, gallant partnering, Martins made himself virtually invisible behind Farrell despite his impressively large, stereotypically "Danish" build. He made obvious his mission and primary goal to present her, in all her glory, to the audience. Martins guided Farrell's every move with what appeared to be the slightest touches of his hand or the gentlest strokes of his arm. Slightly taller than average and waif-like in build, Farrell seemed to float effortlessly in his hold. She always appeared comfortable, confident, and free to be daring. George Balanchine (famous choreographer, director, and founder of the New York City Ballet) is said to have preferred that dancers in most of his ballets refrain from exhibiting overtly expressive gestures suggestive of romantic love, and we see this clearly in Martins' and Farrell's example. In video footage of Balanchine's *Chaconne* (c. 1978) and "Diamonds Pas de Deux" (c. 1977) for instance, they partner flawlessly, yet barely make eye contact. Their quiet, unforced connection is nevertheless tenderly poignant and palpably intense. With a sensitivity heightened, perhaps, as a result of Balanchine's mandate of the dancers' emotional reserve, the two manage to remain physically attentive and instinctively attuned to each other throughout their entire performance. Viewers

1 Anna Kisselgoff, "Ballet: Gelsey Kirkland Is Back; Baryshnikov Restages *Giselle*," *New York Times*, May 1, 1981.

can immediately sense their trust of one another, and we are both excited and comforted by the subtleties of their familiarity and mutual confidence.

Jock Soto and Wendy Whelan

Particularly manifest in Christopher Wheeldon's choreography, Soto and Whelan move and breathe in remarkable unison like halves of a single organism. Their concord makes the most complex and intricate passages appear seamless. We find the ease and tranquility of their *pas de deux* work spellbinding. Similar to Martins, Soto manages to appear invisible in relation to his partner, discreetly punctuating and highlighting Whelan's movements as he showcases her. He makes the difficult look easy and the complex seem simple. When we were initially taught Wheeldon's *Liturgy* (one of his most breathtakingly beautiful *pas de deux*), we fought and fumbled through the demanding complexities of the partnering. Upon seeing Whelan and Soto dance it, we were astounded by how smooth, simple, and effortless this duo made it look. Their bodies melded flawlessly and synchronically as perfect mirrors of one another's movements and breath. Carlos and I used their example to map out our own intentions for the *pas de deux*. Soto and Whelan gave us an exemplary ideal to strive for.

José Manuel Carreño and Julie Kent

Carreño's elegant masculinity, ardent yet refined, matched with Kent's sweet, modest nobility and grace embodies for us the perfect partnership. In our opinion, acrobatic partnering tricks and technically astounding physical feats are never warranted, nor missed, when these two purists are paired. The richness and sincerity of their dancing is magnified by the honesty that radiates from them. They always seem coupled in deep conversation, genuinely "speaking" with one another though their eyes. They have created for us the ideal example of a meticulously developed and artistically accom-

plished relationship—one founded upon profound artistic respect and maturity and epitomizing the type of partnership we endlessly strive for.

Franklin Gamero and Iliana Lopez

Former stars of the Miami City Ballet, Gamero and Lopez, as a husband and wife team, possessed remarkable mutual understanding, both on and off stage. Their deep commitment to each other shined through their partnering, and their communication was always admirably respectful. They never raised their voices, and their patience with one another seemed constant and limitless. They resolved their issues quietly, and they saved disagreements for private discussion. Their *pas de deux* work, both in the studio and on the stage, was immaculate and pristine and demonstrated unfailing consistency. Regardless of the circumstances, Gamero and Lopez were able to communicate with one another through the dance more precisely and instantaneously than any other couple we have known. Though they retired from Miami City Ballet in 2004 and currently direct the Gulfshore Ballet in Ft. Myers, Florida, we remain friends and visit them often. This unassumingly humble couple still serves as our daily role model, as they have for years.

Fred Astaire and Ginger Rogers

These musical film and dance icons created one of the greatest and most famous dance partnerships of all time. While not classical ballet dancers, Astaire and Rogers nonetheless personify *pas de deux*, epitomizing its definition of "two dancers flowing together effortlessly." Perfectly paired in talent, temperament, and charisma, Astaire and Rogers, seemingly as light as air, glide together across the dance floor. In the ten films they made together between the 1930s and 1950s, they were so intuitively connected and at ease with one another that they made their intricately choreographed half–tap, half–social dance routines appear entirely spontaneous and natural, as if the steps had

occurred to them right on the spot. Their obvious joy of movement and their playful musicality made them the box office gems they were, and as we watch them "tear up the floor" in their films, we are reminded that partnering provides dancers of many genres a platform for taking their love of dance, and the expansion of their expression within dance, to a whole new level.

10

~

Etiquette Check List

Reviewing basic partnering protocols

There exist certain social graces in *pas de deux*, or rather an unspoken partnering "code," that dancers usually expect from their partners and to which they hope their partners will adhere. Unfortunately we have found that some dancers carelessly ignore even the most basic civilities, regarding them as dispensable formalities. While politeness and courtesy are not mandatory, common sense indicates that the more consideration partners show one another, the more pleasant their experience dancing together will be. The guidelines we elect to point out here contain etiquettes that can be easily adapted to one's daily routine and readily applied in just about every circumstance. These etiquettes have had a repeatedly positive impact on our safety and comfort and have made our partnering experiences all the more enjoyable.

Perfumes and colognes should be used conservatively, as they can potentially cause respiratory discomfort, headaches, and even allergy attacks. Whether dancing alone, with a partner, or in a group, a light spritz will usually suffice. Elevated body temperatures and perspiration will typically intensify a fragrance's potency anyway.

Both males and females should invest in an effective underarm deodorant. Dancing is a sweaty business and pungent personal aromas

abound. Even the most unpleasant odor can be nipped in the bud, however, long before it becomes unbearable.[1] Practicing good hygiene also calls for wearing fresh, clean rehearsal garments. Dancers should include an extra set—or two—of practice clothes in their bags and make a conscious effort to change soggy leotards and T-shirts as often as possible.

In the interest of safety, dancers *must* refrain from wearing bulky jewelry. Adornments should be kept small and inconspicuous. A simple wedding band–style ring will not typically cause any problems, but long necklaces, chains, dangling charms, bracelets, anklets, watches, large rings, and even certain earrings can get caught in fingers, hair, and clothing, causing accidents. They can easily inflict bruises, scratches, and other injuries. If a role requires that a dancer or a dancer's costume be embellished with jewelry, the dancer should wear the costume (or its accessories) for as many rehearsals as possible so that his or her partner may adjust to any garment-related challenges.

To avoid embarrassing their partners, polite dancers will conscientiously refrain from addressing any awkward (and usually unforeseen) human "disgraces" that may occur during partnering. Slips of the hand and irrepressible biological functions (which typically produce embarrassing noises and/or smells) do happen and are just some of the realities dancers have to accept. No good will ever come of shaming or ridiculing one's partner. Exhibiting professionalism and maturity as a team includes accepting such incidents, getting used to them, laughing together about them, and, most importantly, getting over them.

Dancers should opt to rehearse in clothing most similar to the costume in which they will perform. Bulky attire may hinder movement and prove bothersome. In particular, if one will be required to sport pants, a long skirt, or a jacket on stage, then—without a doubt—the dancer should wear these or similar garments during studio

1 Deodorants containing baking soda very effectively absorb odors. For ladies, "stick" or "solid" variety deodorants are a more practical choice than gels, creams, and roll-ons that can leave a dangerously slippery residue behind.

rehearsals. Dancers must also be aware that layers as well as certain fabrics may change the feeling and mechanics of various steps. The more both dancers can practice with them beforehand the better. Conversely if a *pas de deux* calls for a "tank style" top, a bare chest, or bare legs, the dancers will need time to find ways to safely negotiate slippery, sweaty skin. A slick skin surface will likely make certain grips significantly more challenging to secure and sustain.

Dancers should forego the use of body lotions, oils, creams, and gel deodorants. These products make skin slippery and palms slimy and can increase the risk of accidents. If a gel, mousse, or other hair product has been applied, a dancer must be sure to wash the residue off his or her hands before partnering. The same rule of handwashing applies after the use of liniments or warming/cooling ointments, gels, and creams. While these products are wonderful for soothing muscles, their harsh ingredients may burn or irritate sensitive areas (like a lady's underarms) or cause serious allergic reactions.

If passionate kissing is called for within the choreography, a couple should discuss exactly when they intend to switch from "marking" to rehearsing it "full out." Both parties ought to be in accord with the plan and courteous of each other's sensitivities and hesitancies, discussing what might make the situation more comfortable. Each dancer should respect the other's wishes, and neither should feel pressured to rehearse the kiss more often than both are truly comfortable with.

In general, dancers should refrain from smoking and consuming particularly pungent foods before partnering (i.e., onions, vinegar, garlic, coffee, and alcohol). The odors associated with these are very hard to mask. They can be extremely unpleasant and often nauseating for a partner who is in close proximity. Thoughtful dancers will usually brush their teeth, gargle with mouthwash, or suck on a breath mint a few minutes before rehearsals and performances, regardless of whether or not they have recently eaten.

Ladies should be conscious of the demands of the choreography in choosing a type of leotard. Certain materials, such as shiny Lycra®, often prove uncomfortably slippery to handle. Gentlemen may

find it difficult to secure their grip during lifts if the fabric does not provide adequate traction. Leotards designed with intricate side and back straps can also be a hazard, as a gentleman's fingers can easily get tangled in them.[2] Dancers should also be aware that trendy, risqué leotard styles have a tendency to shift during partnering, accidentally revealing areas that are best left covered for the sake of everyone's ease. With both comfort and functionality in mind, it is best when partnering to keep dancewear simple, clean lined, and modest.

Wearing durable, supportive *pointe* shoes (comfortably broken-in but reinforced and hardened if necessary) will benefit both parties. Because a ballerina is usually *en pointe* for prolonged periods during a *pas de deux,* her shoes will wear out easily and quickly. As the *pointe* shoe breaks down, her weight will begin to sink into her feet and ankles and her balance will be harder to find and control. Repeated or prolonged reliance on "dead" shoes during *pirouettes* and *promenades* can also be dangerously detrimental to the tendons, ligaments, and the small bones in a dancer's feet. Lack of adequate support *sur les pointes* can result in both temporary and chronic injury.

Fingernails have the potential to turn into dangerous weapons during partnering. Dancers should keep them at a modest length or someone may inadvertently get poked in the eye or scratched. (I learned this lesson the hard way once when my grip slipped on my partner's sweat-soaked arms. Four of my nails raked their way down his arm, deeply scraping his skin. I felt terribly sorry as he bled and winced in burning pain. The memory still makes me cringe.)

Ladies must be mindful about becoming overly dependent on their partners. The gentleman's job is to *assist,* not to act as the lady's prop, crutch, brace, or primary foundation. It can be extremely hard for the gentleman to maintain his own balance and control (and thus, the lady's) if he is being pulled, pushed, or leaned into at inopportune moments. A lady should take the same mindful and delicate approach to her partner's support as she would to a lightweight freestanding *barre* in technique class.

2 This is also a risk with certain wrap-tie skirts.

In leading confidently and assertively, gentlemen must take care not to aggressively pull, push, or shove their partners. With light pressure, gentle movements, and smooth physical gesture alone, a gentleman may effectively direct his partner in a manner she will be able to feel, correctly interpret, and then respond to.

When ladies sense their partners signaling the initiation of a movement or leading them in a specific direction, they must be careful not to resist. Counteracting her partner's lead by pulling away or trying to take over can result in clumsy, uncoordinated movements and mishaps.

Ridiculously obvious though it may sound, it must still be said: a gentleman must do his very best *NOT* to drop his partner. When or if a dancer is carelessly dropped, depending on the severity of the fall, fully regaining confidence may take tremendous effort. In a worst-case scenario, if the lady actually slips from her partner's grasp, he should, at the very least, try to hit the deck first in an attempt to break her fall. Drastic times call for drastic measures, and that will sometimes mean the gentleman's grabbing for random body parts or costume pieces to ensure his partner's safety (which should always be his top priority and concern).

Patience and good manners should be commonly practiced between partners, and friendly smiles are always welcomed. Sensing that one's partner would rather be dancing with someone else can be incredibly disconcerting. A positive attitude and willingness to work through obstacles *with* your partner can be the first steps toward a positive experience and, hopefully, a great partnership.

Persistent blaming, criticizing, insisting, and bickering are all wastes of time that do nothing more than generate anger and frustration between partners. In the end, such tactics never really help resolve problems. The sooner a couple realizes that *one person is never solely to blame* for mishaps, the quicker they will be on the road to improving by working out difficulties as a team.

Dancers must not allow an audience to distract them, whether the general public in the house or fellow colleagues on stage, in the wings, or around the studio. Diversions can be very dangerous.

While engaged in a *pas de deux*, both dancers must completely focus on dancing *with* and *for* each other. Outside energies and forces ought not be allowed to penetrate the barriers of concentration built up between them. If two dancers commit equally to an exclusive mutual attention, their resulting partnering work will be safer, smoother, more coordinated, and all the more gratifying.

Most important for all dancers to keep in mind is that their adherence to basic courtesies sends a strong and definitive message. It signifies a professional respect and regard between partners, both as dancers and more importantly as people. It serves as a great first step toward building a solid bond based on good manners, understanding, confidence, and trust. As a result, the hours partners spend rehearsing and performing together should be much more pleasant and productive.

11

~

Examining *Promenades* and Off-Balance Work

Generally *promenade* means to turn while walking. In ballet the term is used to describe a dancer rotating slowly in place on one foot, using slight movements of the heel to propel the body around while holding a definite position such as an *arabesque*. In *pas de deux*, a *promenade* is a partnered step in which one dancer—typically the female—holds a position on one leg while her partner walks a small circle around her, usually holding her by the hand or waist, to turn her slowly. The gentleman's principal focal point during a *promenade* should be his partner's axis, as he carefully maintains the imaginary circumference of the circle he is walking around her. If he cuts the perimeter by stepping toward her, he will inevitably knock her off her axis. Conversely, if he makes his circle too big, he will typically pull her off her axis toward him. Even if she is leaning off balance, her axis must remain constant for the duration of the rotation. He must also hold her arms in the proper position: there should be as little weight as possible placed on the arms, hands, wrists, or elbows and the grip should be light, not at all tense. The only sustained rigidity should be in the locked position of the shoulders.

Several techniques can be used to help the gentleman find and maintain the lady's balance, which will in turn help her feel more

secure. For example, during a standard one-handed *promenade*, softening and curving the elbows enough for the arms to form an S-shaped arc will allow the dancers to keep their shoulders square to one another and remain face to face as the *promenade* rotates. The intricacies of hand-to-hand grips are also important; establishing a grasp with wide, flat, open palms better enables dancers to keep their wrists straight, guarding against any bending or collapsing that can throw off the balance. If the lady feels she needs some extra support, the dancers may each extend their fore- and middle fingers in the grip, elongating them along the inside of their partner's wrist. This nearly imperceptible shift in grasp usually acts as a bracket, adding a significant amount of stability.

For two-handed *promenades*, the gentleman positions himself either directly behind or in front of the lady and holds her by the waist, by both hands (as in a standard *promenade à la seconde, face á face*), or by the back. When supporting her at the waist, he should focus on maintaining the neutrality of her pelvis and refrain from pushing her forward of her supporting leg or pulling her backward off it. The only shift in pelvic alignment he should help her make is in executing steps such as *arabesque penché*, where he initiates both the descending and ascending actions by using his hands and wrists to tilt her pelvis slightly. If he is promenading her in the *penché* position, he will need to maintain the backward tilt of her pelvis for the duration of the *promenade*, shifting and uprighting it only to signal to her that it is time for her to return to an upright posture. Ladies should note the importance of maintaining proper technique while rising from the *penché*: lifting the back while maintaining the *arabesque* leg in its locked position. If the leg begins to drop first, not only will the line be lost, but the gentleman could abruptly lose control of his partner's center. When a *promenade* requires the support or grip to be placed at the lady's back, her hips generally face the gentleman's while her torso is bent backward in cambré, a convex bend of the upper back. Her hips should remain square to his throughout the rotation, and he should offer his support by forming a wide triangle with his arms perpendicular to his torso and his palms supporting her lower back,

providing her a shelf on which to lie backward. To bring her up from the *cambré*, he may initiate the action by tilting his wrists forward and toward himself, allowing her to use her abdominals to pull herself up to stand straight. In a *promenade à la seconde, face à face*, where the support is created by the hands, the gentleman should place his arms in a low *demi-seconde* with his palms facing up, providing resistance with an ever-so-slight upward pressure. The lady places her palms down onto his, pressing down slightly and evenly on both sides using the lateral back muscles rather than the arms themselves. While the back and shoulders are held tight, the arms should actually stay quite relaxed. Again, both dancers should keep their shoulders square and maintain the face-to-face position throughout the revolution.

There are countless variations on the standard *promenade*, and in more contemporary works, specifically, *promenades* are often done off balance. This requires great physical sensitivity, counterstabilizing skills, assessment, and control from both dancers. It is always best to become comfortable with standard *promenades en balance* before attempting those that are off balance and, consequently, more physically challenging. Off-balance steps in general, whether stationary or turning, require the dancers to find and maintain a secure counterequilibrium, or an equal opposing outward pull between the two dancers. While there are always exceptions to any rule, the lady typically occupies the more passive position based on choreographic demands, allowing the male to initiate and guide the movement. If a revolution is required, she is usually expected to lean into the circumference of the turn and away from her partner's opposing force. This must happen, however, as a result of her partner guiding her into the turn, not by her own initiation of the movement. Since gravitational pull, momentum, and velocity all play roles in the turn once she is off balance, she must allow her partner to dominate, establishing the bounds of the *promenade* to maintain control of her speed, axis, and center of gravity. If the step calls for the female's leg to be lifted, both dancers must be aware that she will need to lift her leg *before* she is leaned off her center. Once gravitational pull comes into play as she inclines outward centrifugally, her leg will begin to feel

heavier, making it increasingly difficult for her to raise it to full height. Remaining aware of and sensitive to this detail, the gentleman should allow his partner ample time and opportunity to raise her leg to at least a ninety-degree hip height *before* guiding her off balance.

Here we provide examples of two off-balance extensions and a drag to practice that we believe may help dancers feel comfortable counterbalancing before attempting off-balance *promenades*, in which the rotation and centrifugal force add a significant degree of complexity. Please take note that in each instance, as can be seen in the photos, there is very active and consistent pushing and pulling energy and equally counterbalanced teamwork at play. It is clear how, though the gentleman initiates the action, the two bodies lean out in opposite directions simultaneously, providing the balance and weight distribution needed to either maintain or move the pose through the *promenade*. If one dancer anticipates the shift, preceding the other's actions, the balance will be thrown off immediately. Since the gentleman is typically the heavier and more massive partner, he will need to lean outward a bit more slowly and with great control so as not to inadvertently pull the lady off her leg toward him.

Penché arabesque with an Off-Balance Pull-Away

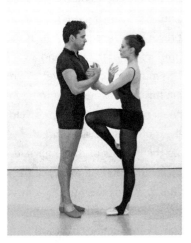

- The dancers prepare by standing face to face in close proximity with a one-handed grasp (in this case, the lady's left hand to the gentleman's right). The lady has her right leg up in a parallel *passé* position.
- The lady begins by turning her legs out to a *passé en dehors*. As she begins to open up to her *développé arabesque*, the gentleman slowly begins to lean her outward as he lunges

back in the opposite direction. Both dancers apply equal opposing force on the arm-to-arm grip, but the lady must not grip so tightly that she cannot straighten her elbow.

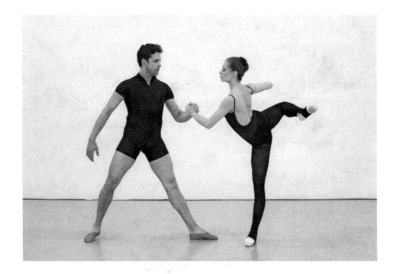

- The gentleman continues leaning the lady outward as she stretches her arm and leg to their fullest extension. By the time she is in her final position he should have also reached his maximum lunge.

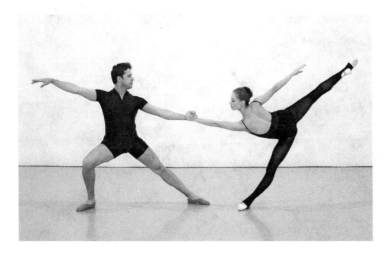

Développé en avant with Off-Balance Lean-Back

- The dancers prepare by standing face to face in close proximity with a one handed grasp (in this case, the lady's right hand to the gentleman's left hand). The lady has her left foot back in a "B-plus" position.
- The lady begins her *développé en avant* as she bends her standing right leg in *plié*. Once she has gotten her leg to an *attitude* at hip height, the gentleman can begin leaning her out and back, off her leg. He simultaneously begins his lunge backward in the opposite direction.

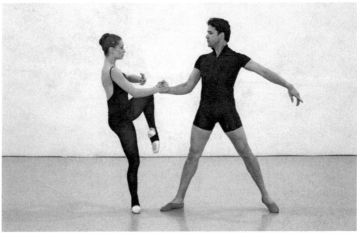

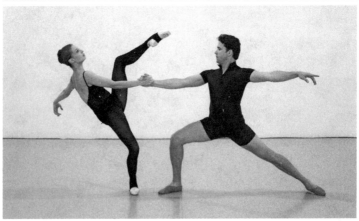

- As the gentleman continues to lean her out with control, the lady stretches her elbow and fully unfolds her leg to the front. The dancers should feel they are giving equally opposing force to the pull-away.

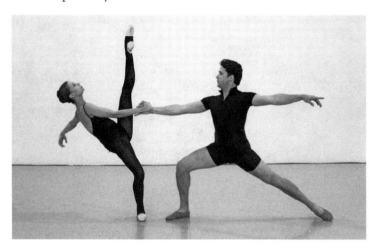

Slide with *Fouetté* to *Penché* (*troisiéme arabesque*)

- The dancers begin in a standard *first arabesque* position with the gentleman directly behind the lady, supporting her at the waist.

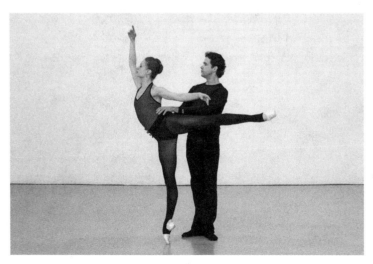

- The gentleman bends his knees down into a *plié* and changes his grip, reaching his right arm around the lady's waist and his left arm around her back leg.

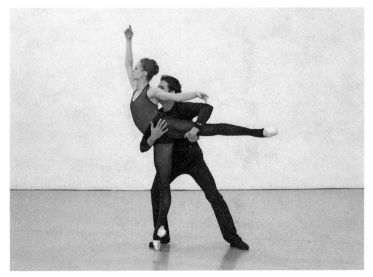

- The gentleman straightens his knees and lifts the lady off the ground, maintaining a slight diagonal tilt to the ground in preparation for the slide as the lady closes her legs into a fifth position.

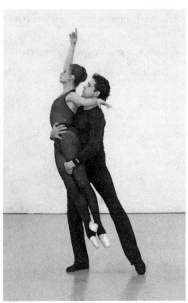

- The lady keeps her legs closed and her center taut as the gentleman makes a slight lunge and guides her body into a slide in front of him. He should slide her so that she just passes his back (left) leg.

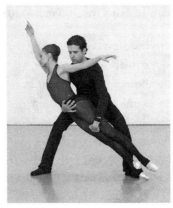

- The gentleman brings the lady back up to standing position and helps her to *fouetté* (flip) to her *third arabesque* by switching to a two-hands-to-waist grip. The lady opens up her right-leg *croisé devant*, aiming it to the upstage left corner and—trying to keep her toe in a keyhole—opens up her left shoulder as the gentleman brings her around to complete the full *fouetté*, finishing in a *third arabesque*. If a *penché* position is desired, then the gentleman must use his wrists to help her tilt her pelvis so that she may stay forward over her balance.

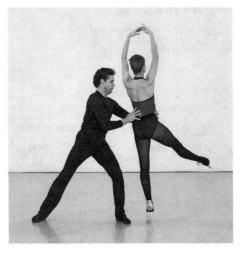

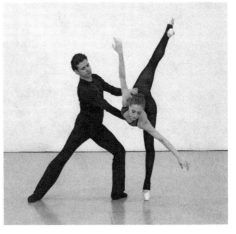

Hip-to-Hip Drag in *First Arabesque*

- The dancers prepare side
to side, hip to hip, with
the lady up *sur les pointes*
in fifth position. Her left
arm reaches around his
neck to rest on his op-
posite (in this case, left)
shoulder. The gentleman
uses his left hand to sup-
port her left hip, and his
right arm reaches around
her back to wrap around
her lower waist.

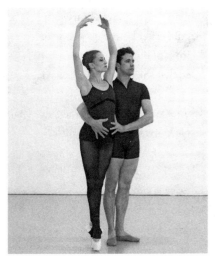

- As the gentleman takes a
step forward onto his right foot, knees bent in *plié*, he angles his
hips out slightly so the lady may rest her left hip on his right hip
to secure her position as she is leaned forward off her balance
and raises her right leg to the back, making a *demi arabesque*
line.

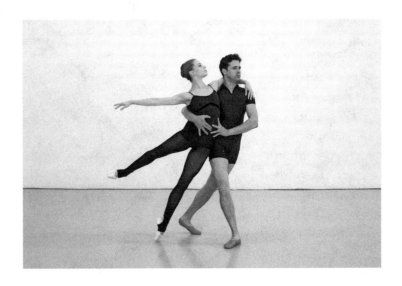

- The gentleman continues to lunge forward on his left leg (or, depending on the choreography, walks several steps to end in the lunge) as the lady keeps her hip glued to his, pressing down slightly on his shoulders with her left arm for added support. If she feels secure enough, she may let go of his shoulder and extend her arm forward in a typical *first arabesque* line.

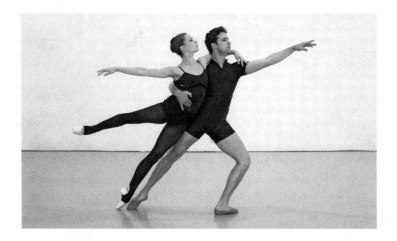

There are countless off-balance drags, slides, and *promenades*—more than we could ever list here—that surface in neoclassical and contemporary choreography. These are just a few intermediate-level examples to try out to begin to get the feeling of a counterbalanced effort. Do remember that before attempting any off-balance work, dancers should feel confident with handling standard, properly balanced *promenades*. Once partners are secure with the basics and become more familiar with one another's shifts in weight and other tendencies, they can move on to the more exciting challenges involved in performing off-balance steps.

Two Handed Promenade in Ballet
See a video example of a complex *promenade* in *attitude derrière*, similar to one which concludes the lush second movement of George Balanchine's *Concerto Barocco* ©The George Balanchine Trust.

12

Understanding the Basics of Partnered Turns

Partnered turns are fundamental to the art of *pas de deux*. In one form or another, they appear in just about every choreographic work and can be executed in any number of different ways, in different directions, and from different positions. Because we cannot possibly touch base on all of them here, we begin by discussing the basics that serve as a foundation to build upon and continue with examples of more complicated variations as the chapter progresses.

To understand the basics of a partnered *pirouette*, dancers should realize that standard rules apply to just about any sequence of turns. The lady's responsibilities include taking off with sufficient impetus (not too forceful but not at all sluggish) and arriving at her *retiré* position as directly and immediately as possible with the tip of her right toe placed in the "hole" at the top of her left knee. All the while, she must keep her body drawn compactly together in "one piece." She will be required to hold her center strong, maintaining the sensation of being pulled up through her waist and spine (that is, vertically out of her hips). Then she must lock her *retiré* position into place and use her head to spot as if she were turning on her own. Her arms must remain pulled in tightly toward her body so as not to interfere with her partner. If her arms need to be in an overhead fifth position, they must arrive there by skimming as closely to her body as possible to

avoid hitting her partner in the face. They may cross on the way up if necessary. She must be mindful of maintaining her own vertical axis to the best of her ability without tilting forward, backward, or sideways.

The gentleman's main responsibility is to determine whether or not the lady has used sufficient force in preparing for the required number of revolutions and to adjust her speed accordingly. In some instances he must help her shift her weight to a one-legged *relevé* from a two-legged flatfooted preparation and, as she turns, keep her center of gravity straight on that exact vertical axis, making corrections as necessary. What he must *not* do is paddle her around by the waist in an effort to squeeze in as many turns as possible. Quality does, and always will, outweigh quantity. The lady should never appear to be "manhandled."

Especially where contemporary ballet choreography is concerned, dancers should be aware that the variety of supported or partnered *pirouettes* may be a bit different from those they are used to practicing. Partnered turns are always evolving, veering away from classical ballet's textbook rules and positions. Today's dancers are often required to forego the safety net that careful preparations and definitive positions provide. In classical ballet there is typically an established and well-defined moment of readiness, at which the lady organizes herself into a preliminary position or stance, and the gentleman sets himself up securely behind her before they proceed with the turn itself. When the revolutions are complete, the gentleman decisively stops the lady in a precise position before moving on to the next step. Contemporary choreography, by contrast, demands quicker, more seamless transitions between steps, including passages involving *pirouettes*. Dancers must often take off with little time to prepare, sometimes from random, off-kilter stances or even as they are still transferring their weight out of the previous movement. The lady may also be expected to turn in any array of positions other than the common *retiré*. All of these demands impact her center of gravity. Because the lady's balance is usually precariously centered over the tip of her *pointe* shoe, the gentleman must be especially sensitive

to her timing and aware of changes to her center of balance and axis. This "uninterrupted" movement paradigm is similar to the transitory patterns often seen in ballroom dance, where one movement sweeps fluidly into the next without the dancers noticeably stopping to rethink, reposition, or readjust.

Working to become comfortable, confident, and polished in the following basic turns will ready dancers for the challenges of the more demanding *pirouette* sequences they will encounter in choreography. Once the fundamentals are well established, dancers can experiment with more complex variations.

Turning from a Typical Fourth or Fifth Position

- As the lady prepares in a fourth (left foot forward) or fifth (right foot forward) position *plié*, the gentleman stands behind her, about half an arm's length away, with his legs in a relaxed *demi-seconde* position. His hands may be placed at her waist, or his arms may remain out in an *à la seconde* position (as called for in the *Balanchine* style).
- The lady proceeds to take off for the turn just as she would if she were on her own.
- If the gentleman starts out with his hands at her waist, he immediately helps her shift her balance over to her supporting leg.

Though not always necessary or required, he may also help her add impetus to the turn by first shifting his right hand forward slightly during her preparation and then pulling it back along her waist in the same direction of the turn as she takes off. Should he choose to do this, the movement must be a very slight one, and his hands should remain level and equidistant at all times. When

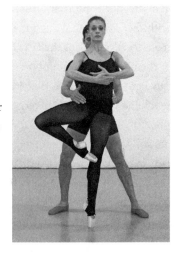

the gentleman prepares for the turn with his arms extended out to the side, the technique changes a bit. He allows the lady to complete one or two revolutions on her own and then carefully brings his hands to meet her waist, precisely timing himself to keep her revolving smoothly on her leg without knocking her off balance. He may then slow her turns down or speed them up, as necessary.

- If multiple *pirouettes* are the goal, the gentleman's hands should follow the lady's turn, helping her revolve on her own axis and propelling the turn by guiding her with a light, repeated pulling action in the direction of the turn (done with the right hand for *pirouettes en dehors* to the right) while the other hand stays steady and maintains her balance. In all circumstances his elbows should remain down, and he should try to guide the lady's body within the semicircle created by using the thumb and forefinger of his left hand or, should he prefer to keep his thumb aligned with the rest of his fingers, the cup of his left hand. (Thumb placement is optional and based on personal preference.)

- As the momentum dwindles, or when the set number of turns has been completed, it is the gentleman's responsibility to stop the lady securely *en pointe* by pushing gently and equally with both hands inward on her waist. While the grip should be firm, there is no need to squeeze. He must be sure to keep her on her balance, supporting her as necessary, so that she may proceed smoothly to the next sequence of steps.[1]

1 As a variation on the ending of a standard *pirouette* where the gentleman stops the lady to face the audience, he can stop her to face himself instead. The lady raises her arms to a high fifth position while turning, and, as the gentleman stops her, she lifts up out of her waist to *cambré* back, changing her foot from *retiré devant* to *retiré derrière*. The gentleman helps her achieve the *cambré* position by sliding his hands upward from her waist at the end of the turn in order to support her upper back as well. Once she hits her position, he walks a small clockwise circle around her, promenading her in the backbend. He uses the upward tilt of his wrists, along with the strength in his palms, to help her bring her torso back upright at the end of one revolution while pulling back on her right hip to help her rotate to face front again.

Finger Turns

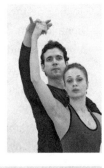

- The lady begins in fifth position *sur les pointes* with her right leg forward, directly in front of the gentleman. She extends her right arm upward, slightly forward of her head, with her fingers lightly closed to make a hole for the gentleman's middle finger to fit into. Never gripping tightly, she lightly encircles his finger throughout the turn, and her arm stays slightly bent at the elbow. Her left arm extends outward in a *demi-seconde*, with her left palm gently resting in the gentleman's left palm.

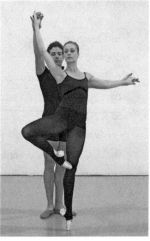

- The lady first assumes a *retiré* position with her right leg up and then continues to fully extend it into a *développé croisé devant*.

- Next, she pushes gently off of the gentleman's left hand—he must offer her adequate resistance—and whips her leg through *à la seconde* to bring it immediately back into *retiré*. Her left hand rounds into a first position and remains there during the turn. The gentleman makes sure to keep his right middle finger placed directly over the center of the lady's head, thereby keeping her arm slightly forward of her center, never back.

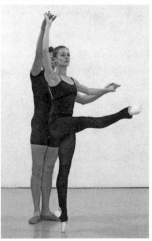

- For speedier multiple turns, the gentleman can push his finger downward into the lady's light grip as the lady pushes her right hand upward slightly to meet the end of

his finger. This action will ensure that his finger does not slip out of her grip with the speed of the turn. Holding her center very strong and compact, the lady should continually push her left shoulder forward and her right shoulder back. The gentleman can assist the turns by making an ever-so-slight clockwise "stirring" motion with his finger and wrist.

- To finish, the lady can either take the gentleman's left hand in hers once again, or the partners can transfer directly into another position or lift.

Finger Turn into Grip in Ballet
View a video demonstration of finger turns leading into an off-balance pull-away in *arabesque*. The instructional emphasis will be on the seamless switch of the grip.

Whip Turns

- The lady begins in either a *retiré* or an *attitude devant* position *en pointe* with the right leg up. The gentleman is positioned directly behind her, supporting her at the waist.
- The lady unfolds her leg into a ninety-degree *développé croisé devant* position as the gentleman assists her by pulling slightly back on her left hip.
- As she reaches the full extension of the *développé*, he helps her open her leg out to an *à la seconde enface* by pulling back gently on her right hip.
- As she circles the working leg to the side in a quarter of a *rond de jambe*, the gentleman continues pulling back on the lady's right hip in order to propel her force *en dehors*, that is, "into" the pirouettes.[2]

2 A series of whip turns can also begin with the traditional finger-turn grip. As the lady opens her leg sideways to her *à la seconde* position, the gentleman lowers her right arm to the side *à la seconde*. His left hand offers enough resistance for her to push against slightly for momentum. She closes her arms into a round first position as the partners let go of the finger grip. Her leg simultaneously bends into the *retiré* position. Upon releasing the finger grip, the gentleman catches the lady's waist with both hands and maneuvers her as he would during a standard whip turn.

Pirouette en dedans from an attitude derrière

- The gentleman will begin in a long lunge in fourth position *effacé*, right leg forward, left leg behind, and arms extended sideways in *à la seconde* with the palms up. His head will face the lady, looking over his left downstage arm.

- The lady will *piqué* into an *attitude effacé derrière* with the left leg lifted, her standing toe placed in line with the gentleman's back foot. She will place her right hand on the gentleman's left shoulder, and her left palm will be in his left hand.

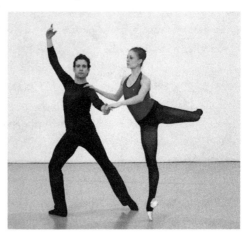

- The lady extends her left leg as she swings it around counterclockwise to *à la seconde*, aligning her pelvis properly over her supporting leg; then she continues bending her knee into a *retiré*. As

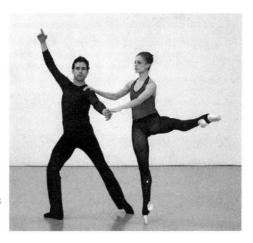

she does this, she pushes lightly off of the gentleman's hand and shoulder to then bring her arms into a rounded first position, without arching or swaying in the back. She holds this position through the remainder of the turn.

- As the lady is pushing off for the turn, the gentleman rises up from the lunge and takes a large step to the left to quickly get behind her and support her throughout the turn. He brings his hands to her waist and supports her balance, just as he would through any other *pirouette*.

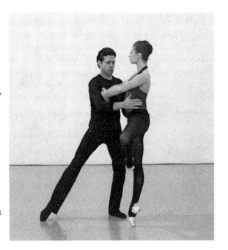

Tour à la seconde into *arabesque penché*

- The lady prepares in a large fourth position lunge, *croisé*. Her weight is forward on her right leg, the right knee bent in *plié*. Her left leg is extended behind, right arm rounded in first position, left arm extended in second. The gentleman stands diagonally behind her.

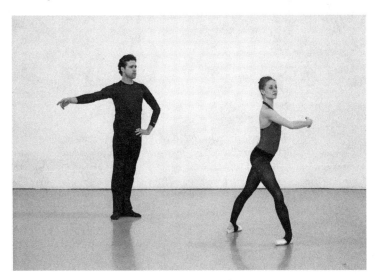

- The lady pushes up into a *relevé* on her right *pointe* while lifting her left leg up to the side to a ninety degree height, arms in a high fifth position. She keeps her torso perfectly straight and, without leaning to either side or sitting into her supporting hip, completes a single unassisted *pirouette en dedans* in *à la seconde*.
- As soon as the lady's left leg has passed him, the gentleman quickly steps in toward her and takes hold of her waist to support her, keeping her on balance for the remaining half of the turn and helping her into the ending pose, typically a *penché fourth arabesque*.[3]

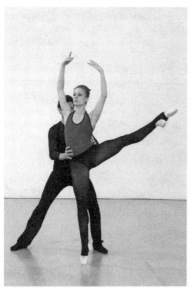 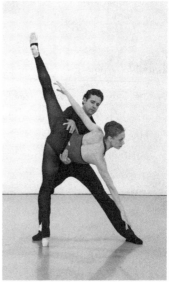

3 The gentleman supports the lady's pelvis as she dips down into her *penché*, allowing it to tilt slightly backward so she may achieve a beautiful line. He must not allow her weight to fall backward, or she will not be able to lift her leg to full height. Instead, he must keep her over her supporting leg and on top of her balance. To bring her back up, he will need to initiate the action by reversing the tilt, using his wrists and manual grip to guide her pelvis back to a neutral position as the lady lifts her back upright.

Chaînés into a Falling Pose

- The lady begins in a *tendu épaulé* with the right leg back, right arm extended forward in *second arabesque*. The gentleman is in a relaxed first position a few feet to her right, his arms extended out in second position.
- The lady takes off for her *chaînés* (travelling short, fast turns in first or fifth position) aiming herself directly at him.
- As she approaches, he adjusts himself as necessary so he can discreetly slide his left hand along the back of her waist, guiding her and drawing her into him.
- As his left arm wraps around her waist, she slows down her turns slightly. He then shifts her over to his right side, bringing her closer to him without disturbing her position. He clasps his left hand with his right and brings her downward into the fall by taking a deep lunge. He bends his right knee in *plié* while his left leg stays extended. His left foot should be placed next to the lady's toes so she doesn't slide as she is lowered into the tilted position.
- The lady brings her legs from first to fifth position, right foot front as she falls, and her arms come up to a high fifth position. If desired she may *cambré*, or arch back, slightly at the end of the fall.

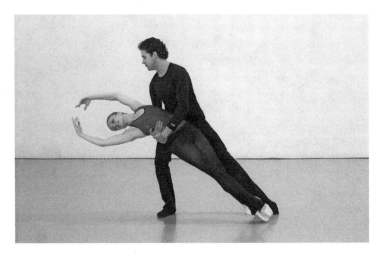

- To get up, the gentleman must push strongly off his right foot by using the strength in his upper leg and, without disturbing the lady's position, come to standing, bringing her back to vertical. He may gently turn her around to the left as he does this, so that she ends facing him in fifth position *sur les pointes*.

Once this standard series of basic *pirouettes* is well practiced and feels secure, dancers can easily take the knowledge, comfort, speed, and timing they have acquired and apply them as they experiment with more complicated turns in varying positions. Assisted turns can be a sensational statement and an electrifying element of partnering, both for dancers and for their audiences. The more a couple practices partnered turning together—learning the intricacies of one another's balance, coordination, and timing—the more fearless and breathtaking their *pirouettes* will become, marking a true turning point in their partnering work.

Learning a Series of Pirouettes
View a video demonstration of a complex *pirouette* combination, including both *en dehors* and *en dedans* turns bookended by shifts onto and off of balance, similar to a series of turns in George Balanchine's *Tchaikovsky Pas de Deux* ©The George Balanchine Trust.

13

—

Exploring Lifts

With the exception of certain social and ballroom dances and ice dancing—where the absence of high overhead lifts distinguishes it from the more acrobatic "pair skating"—lifting tends to be a dominant component of partnered dance. A dancer's ability to lift will not necessarily be determined by strength alone; rather, it requires a good deal of care, patience, and due time to master. Careful positioning of the hands, precision timing, conscious coordination, and deliberate musical emphasis will each play a tremendous role in enhancing one's power and capacity to lift. The partner's contribution to the ascent and descent of a lift will also significantly help or hinder its execution.

For the purposes of this book, we have divided the general category of lifts into five subcategories: simple vertical, traveling, ending in a pose, tossing and/or catching, and complex. We will give examples of each type in order of its difficulty level, defined as "simple," "intermediate," or "advanced." Before tackling advanced lifts, dancers should first become proficient in each of the basics, which will be the first examples listed in each category. Some of the initial lifts may seem rudimentary, but they serve as the groundwork for mastering all the other choreographically complex lifts. In order to correctly approach complex lifts, a dancer must be fluent in the requisites, able to execute them seamlessly and effortlessly. The basics must become

second nature. That said, even seasoned professionals can redevelop bad habits over time, so everyone stands to benefit from revisiting the basics every now and again. In effect, then, these simpler lifts will serve the dancer the way an alphabet serves a word and a word serves a sentence. Once basic technique is mastered, the dancer can build securely upon that base, applying principles consistently, proficiently, and, hopefully, automatically in order to meet the challenges of more intricate lifting.

Before exploring any lift—be it simple, intermediate, or advanced—dancers need to attend to a few reliable guidelines. Here are the fundamentals each partner will want to remember.

Ladies

- Pushing firmly off the ground as the lift is initiated (or actually jumping should the partner prefer or need that) will help the gentleman gain the extra momentum he needs to hoist the lady up to a greater height with less effort. If timed properly, this push and/or jump will help the lady feel lighter, enabling her to achieve the illusion of effortlessness. For maximum impact, the lady should remember to push off from a generous *plié*.
- A lady must try to push off the ground *toward* her partner, not away from him. If she jumps haphazardly, she risks injuring her partner and possibly herself.
- Contracting the abdominals and tightening the core will make a dancer more compact, allowing her to be more easily lifted, tossed, caught, and maneuvered in general.
- If a running start is called for, the lady must be careful not to pass the gentleman before she takes off for the lift, especially if it is one that requires her to jump. Should the lady's preparation fall short, it will always be easier for the gentleman to adjust by stepping into his partner's path rather than to try to catch up to her or "bring her back" from a distance.
- The lady must sense and respond attentively to the gentleman's cues, impetus, and timing, allowing him the opportunity to

lead and initiate the lifting action. Should the lady rush, taking off before receiving her partner's cue, he will be forced to hurriedly catch up to her. In this event the partners' timing will be misaligned and the lift will probably not gain maximum height. For safety's sake especially, the lady should wait for her partner, making sure that he is prepared to lift, toss, or catch *before* she takes off, even if that means falling slightly behind the music.

Gentlemen

- As a general rule with few exceptions, a lower grip is the most effective. It is usually best to start with the hands positioned just below the lady's proper waist, leaving ample room for the grip to slide upward and end in a comfortable, secure position. If the gentleman's hands glide from the lady's proper waist up to her ribcage, it will become difficult for him to control her weight, and she will have a tough time arriving at and maintaining her own position. Additionally, should the gentleman's fingers get caught between her ribs, she can experience pain, bruising, and, in the worst case, a fracture.

- A gentleman must *never* squeeze the lady for added security, especially not around the delicate stomach or ribcage areas. This is a surefire way to cause her pain and possibly even harm. All inward pressure should be safely concentrated around the sides of her mid- to lower waist, just beneath the peripheries of the ribcage.

- There is actually very little strength in the fingers alone, so gentlemen will fare best if they refrain from knuckling or cupping. Maintaining an unforced spread of the fingers will naturally increase the surface area of the hand, providing a more secure grip. For the greatest strength and stability, the majority of inward pressure should be centered through the palms of the hands. (This should also prove most comfortable for the lady).

- While it is the gentleman's responsibility to gently control the lady's landing, making it as gentle as possible, he must not be

afraid to put his partner down assertively and firmly. She needs to feel her weight securely on the ground before moving into the next step. Leaving her dangling helplessly a quarter of an inch above the floor in the attempt to put her down softly will unnerve her and make it impossible for the partners to continue the choreography smoothly.

- Partners should try to time their actions so that they lift *with* the lady's momentum rather than against it. Doing so will maximize the momentum of both, lighten the gentleman's load, and ultimately enhance the lady's elevation. The gentleman must pay close and constant attention to his partner, reading her cues and timing his responses accordingly.

- If the lady will be approaching a lift, dive, toss, or catch from a run, the gentleman must, in his preparation, take into account her distance, visually calculating how much added momentum and velocity such a start will provide her. Accurate judgment will allow him to best brace himself in order to gracefully and steadily absorb the additional impact.

- The gentleman's responsibility does not end the instant the lady touches the ground. She will typically need her partner's assistance as she transitions from the end of a lift into the next step, and the gentleman must guide her smoothly onto her leg and into the direction she needs to go. He should also be aware that, depending on the step, he may not need to push or guide her but simply offer support as she guides herself into the next movement.

Vertical Lifts

Vertical lifts are those in which the gentleman lifts the lady directly upward in a straight, vertical line and lowers her down again along the same trajectory.

Simple: *Entrechat* (crisscrossing of the legs)

- The lady can prepare directly in front of her partner in a fifth position, either flat footed or *sur les pointes,* while the gentleman prepares behind her with his legs open in a *demi-seconde* position. His hands should be placed gently on her waist, fingers pointing inward horizontally toward her navel.
- As the lady bends her knees in *demi plié,* preparing to jump, the gentleman also does a *demi plié* and secures his grip on her waist.
- As the lady jumps, the gentleman follows her upward momentum and lifts her off the ground, adjusting his grip so that the heels of his hands now point slightly downward as his fingers point diagonally upward.
- The gentleman continues to straighten up, keeping his back erect the entire time and stretching his knees until the lady reaches the full height of the lift. Depending on the choreography, the gentleman's arms may either stay bent at the elbows (with the lady at his chest level), or he may stretch his arms fully to elevate his partner higher.
- When the lady senses that she is approaching the height of the lift, she can begin executing the beats or *entrechat.*
- The gentleman then lowers her down gently, bending his knees and keeping his back straight. The lady is generally expected to land in *demi plié,* maintaining her fifth position.

Intermediate: Press Lift into *cambré avec cou-de-pied*

- The dancers prepare *en croisé diagonal.* The lady should have her right foot forward in fifth position, and the gentleman should be standing right behind her with his hands placed gently on her lower waist.
- The lady bends her knees in a *plié* preparation to push off from the floor and the gentleman should *plié* as well, stepping in slightly so he may get "underneath" her as she pushes off for the jump.

- As the lady pushes straight up off the floor, the gentleman should move the heels of his hands inward to meet at the small of her back and press her up over his head as he straightens his knees.
- As the lady feels she is reaching the height of the lift, she should arch her upper back into a *cambré* and bend her left knee to make a *cou-de-pied* position with her left foot.

Advanced: Press Lift in *arabesque*

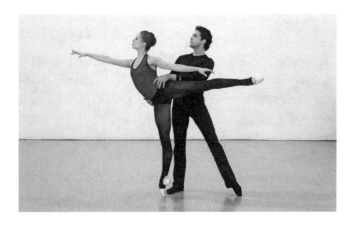

- The lady can prepare by taking a *piqué en pointe* (stepping directly onto a straight leg) to a *first arabesque* position in front of her partner. The gentleman responds by taking a small step toward her, catching her waist to support her balance. The lady should hold her back leg high and keep her center strong enough to maintain her balance.
- When the gentleman senses that her balance is secure, he bends his knees in a deep *plié* (either in a *demi-seconde* position or in a shallow kneel with one leg in front of the other) while quickly adjusting his grip. He should be sure to keep both

hands relatively level: one hand should remain on the lady's waist (fingers pointing slightly upward) as the other switches to the underside of her back *arabesque* leg, palm facing up.

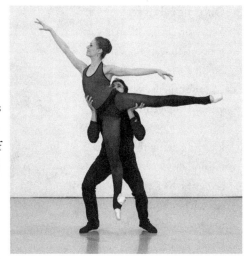

- The gentleman should use the strength in his legs to lift the lady upward as she holds her back up strongly and presses her *arabesque* leg gently downward, resisting the upward pressure of his hand. Her bottom leg can either stay straight, pointing vertically to the ground with the toe resting lightly against her partner's chest, or she can bend it, bringing it into a right angle *passé* or a smaller *coupé devant* position.[1]

- The lady must hold her position, being careful not to collapse or tilt forward in the torso, as the gentleman continues to stretch his knees, straightening up. Using his abdominal wall to keep his back straight, he extends himself to reach the height of the lift by stretching his arms to their fullest length. He must do this without allowing his shoulders to sway or his back to arch. Ideally coordinated, the knees and arms will be stretched nearly simultaneously so that the legs can bear the brunt of the work. This reduces the burden on the arms, shoulders, and back, which is why we use the expression "lift with your legs."[2]

1 Gentlemen might initially try placing the hand which supports the lady's leg higher up on her inner thigh and closer to her torso than they might think necessary. The grip tends to slide outward as the lady is lifted, and it will be nearly impossible to safely readjust while she is in the air.

2 Should the lady feel insecure at first, she may help to stabilize herself by holding onto the gentleman's wrist.

- Once the lady is securely up in the air, the gentleman can proceed to walk forward while holding her aloft in position.
- To lower the lady back to the ground, the gentleman first bends his elbows with control, lowering her with his arms until she is close to his chest level, at which time she should stretch her bottom leg toward the ground. He then bends his knees in a *plié*, lowering her all the way. The lady's toe will touch the ground first; she can either continue onto the next step directly from there, or she may roll through her foot, lowering the heel. She can continue bending her knee down into a *plié*, where it will be easier for her to support her own weight on her standing leg. If she does continue down into a *plié*, the gentleman must make sure that her weight is placed sufficiently forward and over the ball of her foot.[3]

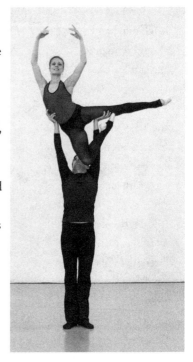

3 An exciting alternative ending to this traditional lowering movement is the "toss and catch" from the height of the press into a "fish" dive. From the peak of the lift, the gentleman tosses the lady a few inches higher into the air and then catches her down in a fish position (see the "Toss and Catch" section for specifics).

Arabesque Press Lift in Ballet
See a video demonstration of a press lift in *arabesque*, followed by a "toss and catch" landing in a fish dive.

Advanced: Inverted Split over the Shoulder

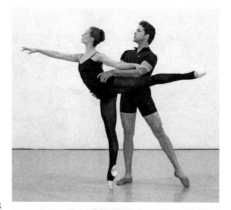

- The dancers prepare with the lady in a standard *first arabesque* position *en pointe* with the gentleman standing directly behind her, supporting her at the waist.

- The gentleman lowers down by bending his knees and then changes his grip. His right arm moves to wrap around the lady's upper hips, and his left arm wraps around her lower hips.

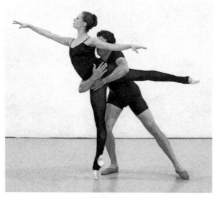

- As he straightens his knees, he begins pushing the lady up and over his right shoulder. When she is approximately three quarters of the way over his shoulder, he changes his grip again, now moving his left hand to support and push her gently under her left thigh. As the lady feels herself moving over the gentleman's shoulder, she should start to bend her back *en cambré* and push her right forward leg to open further into a split.

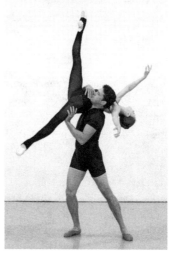

- As the gentleman continues to push her over backward with his left hand, she reaches the full extent of the upside-down position.
- To begin the descent, the gentleman wraps his left arm around the lady's left leg.

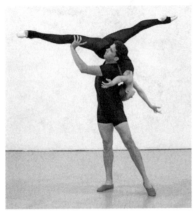 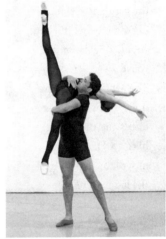

- He continues bringing her back to an upright position and bends back on his left leg to lower her into a fish pose. The lady can bend her right leg back into a *cou-de-pied* to help the gentleman achieve the final position.

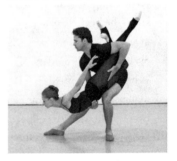

Ballet over Shoulder Lift from First Arabesque
See a video demonstration of the inverted lift described here, comparable to one found in the *pas de deux* in George Balanchine's *Apollo* ©The George Balanchine Trust.

Learning a Series of Ballet Lifts
View a video demonstration of an alternative series of over-the-shoulder inverted lifts, akin to a series found in "The Man I Love" *pas de deux* in George Balanchine's *Who Cares?* ©The George Balanchine Trust.

Traveling Lifts

Traveling lifts include those that take off from one place to land in another. The gentleman typically needs to move the lift by walking or running while carrying or supporting the lady, and the lady needs to hold her position steadily in the air as he moves.

Simple: *Pas assemblé* (assembling the legs in the air)

- Both dancers begin in either a *tendu croisé devant* (forward leg stretched out in front of the supporting leg with foot pointed) or in a simple fifth position, both with the left foot forward. The lady stands directly in front of the gentleman.
- Both dancers should *glissade*, gliding together to the right as the gentleman brings his hands to the lady's waist. The gentleman may prefer to take two steps, right then left, in lieu of a *glissade*. The *glissade* can be directed either horizontally to the side or diagonally to the downstage right corner.
- As the lady takes off for her *pas assemblé*, the gentleman should shift his hands so that the heels of the palms point slightly toward the ground and the fingers point slightly upward (refer to the earlier *entrechat* lift).
- The gentleman then lifts the lady into her *assemblé*, bringing her slightly higher than his own chest height and keeping his elbows pulled in close to his body. He must push with his back (left) arm as he carries her and try to tilt her body so that she can maintain a proper *écarté* position, especially if they are executing the sequence *en diagonal*.
- The gentleman then gently lowers the lady back down so that she lands softly in fifth position, *en plié*. (This entire sequence may be done to the left as well.)

Simple: *Sauté chassé* (side to side)

- Both partners prepare in either a "B-plus" position (left foot front, right foot *coupé* back) or a fifth position with the right foot front. The lady stands directly in front of the gentleman.

- Both dancers *chassé* to the right (right leg extending out, left leg coming in to meet it). The gentleman remains directly behind the lady and brings his hands to her waist.

- As the lady begins her *sauté* (pushing off of the right leg with the left leg up in *first arabesque*), the gentleman takes a small step out onto his right foot and bends his knees into a *plié* behind her in a *demi-seconde* position. He then stretches his knees to lift her up to chest height in the *first arabesque* position. His hands shift so that the back, or following, hand is slightly higher than the front, or leading, hand. This helps the lady support her back, control her legs, and maintain proper position. The gentleman's back foot may extend into either a *demi* (half) pointed or a fully pointed *tendu*.

- The gentleman lowers the lady back down by bending his knees while his hands remain in the same bilevel position. As her supporting leg reaches the floor, he guides her gently backward with his right hand so that they may both continue to *chassé* to the left (left leg extending first, right leg coming in to meet it) and repeat the lift to the other side in the same fashion.

- On the *chassé* to the left, the gentleman returns his hands to a level grip around her waist and, on the *sauté*, he changes once again to the bilevel grip with his back (now right) hand slightly higher than his leading (now left) hand.

Intermediate: *Grand jeté* (large jump from one foot to the other)

- Both dancers prepare with the left foot forward in either a fifth position *croisé* or a *tendu croisé devant*. The gentleman should not stand directly behind the lady, but diagonally behind her left shoulder.

- As the lady takes her *glissade*, the gentleman takes two steps to follow her (right, then left), bringing his hands to her waist. He should bend his knees into a *plié* with his second step in preparation for the lift. As he steps in underneath her jump, he changes his hands so that his left, or back, hand is slightly below her shoulder blade and his right, or forward, hand is still on her

waist. The heels of both hands
should be directed diagonally
toward the ground, and the
fingers should point diagonally
toward the ceiling.

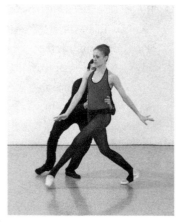

- The lady should bend her knees
 in a strong *demi plié* at the
 end of her *glissade* to give her
 strength to perform a *battement*,
 kicking her right leg forward
 while pushing off her back (left)
 leg into a *grand jeté*. She must be
 sure to jump *straight up*, being careful not to travel forward and
 away from her partner's grip. Should she need additional help
 supporting herself, she can hold onto her partner's wrists as he
 lifts her. Otherwise, her *port de bras* should remain steady in a
 standard *first arabesque* or rounded overhead fifth position.
- The gentleman must then quickly stretch his arms upward,
 hoisting the lady up above his head, using his legs for added
 strength. He should be careful not to move in front of her in the
 lift, or he will be in an incorrect position to lower her back down
 centered on her leg.

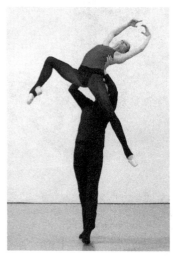
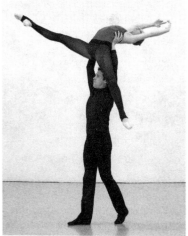

- The shape of the lift should emulate the arc of a rainbow and, as the lady's front leg completes the arc, the gentleman can lower her down to the ground softly so that she ends in a soft *plié* in *first arabesque*, with her balance forward and on top of her legs. She should now be able to support her own weight and feel her own center of balance securely enough to continue on to the following step.[4]

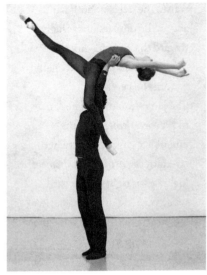

Advanced: *Grand jeté en tournant* (turning the corner)

- Both dancers prepare in a *tendu croisé derrière* position (the back leg extended out straight behind the supporting leg, foot pointed), right foot back and left foot forward. The gentleman should stand in close proximity

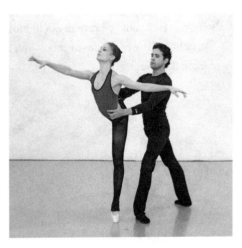

4 As an alternative, the lady can *développé* her left leg forward instead of brushing it straightened in a *battement*. She can arch back slightly as she is being lifted and bend her left leg in an *attitude derrière*. The gentleman supports her with his two hands evenly placed at the small of her back, heels of the hands together.

to the lady, diagonally behind her. Alternatively the lady can take a *third arabesque* position *en pointe*, and the gentleman will support her at the lower waist.

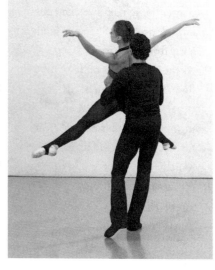

- The lady bends into a *plié* on her left leg as she steps backward diagonally with the right foot in a *glissade*. The gentleman moves along with the lady in the same glissade, or he may take two simple steps instead, right then left, keeping a bit of space between them so he has ample room to lift her. As he does his *glissade*, he brings his hands in to support her waist, but as he lifts her he may find it helpful to readjust his grip, positioning the left (or back) hand slightly higher than the right to support her just underneath her shoulder blade. The right (or forward) hand, however, should remain on her true waist. Again, his fingers should be pointing diagonally up toward the ceiling, heels of the hand directed diagonally down toward the ground.

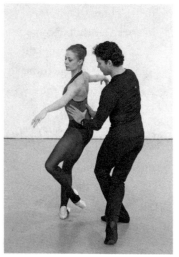

- The lady steps underneath herself to push off from her left foot as she brings it in directly behind the right.

- Changing the direction of her upper body now to face forward, she should either *développé* her right leg forward or do a *battement* with a straight leg to make a *grand jeté*. Her back leg may either remain stretched out in *arabesque* or be bent into an *attitude* position. She must jump directly up and not forward or away from her partner's grip.

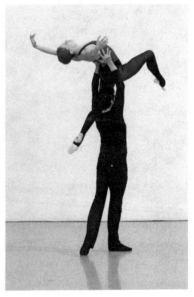

- As the lady pushes off the floor, the gentleman needs to get underneath her. Bending his knees into a deep *plié*, he uses the power of his legs to help him stretch his arms upward quickly, lifting her above his head.

- The lady's body should arc slightly backward (to varying degrees, depending on the choreography), and her front leg should come around to point toward the opposite downstage corner.

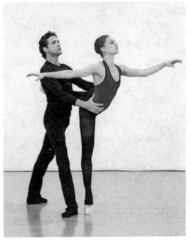

- As the lady reaches the full height of the lift, the gentleman should carry her weight until she is properly directed toward the opposite downstage corner, taking a few steps, as necessary. Smoothly shifting the bulk of her weight from his back (left) arm to his forward (right) arm, he then lowers her gently so that she lands in a *croisé third arabesque* position, either *en pointe* or flatfooted in a *plié*.

Ending in a Pose

A lift that ends in a pose usually focuses on the dancers' final position rather than on the lift itself as its highlight. Lifting in such cases is done solely to achieve a beautiful final position.

Simple: Fish (*poisson*)

- The dancers prepare in a *tendu croisé devant* with the left foot forward, the gentleman diagonally behind the lady at about arm's distance away.
- The lady steps forward on her left foot and *piqués* up to a *first arabesque* position on her right leg. Her back (left) leg is raised up at ninety degrees. The gentleman follows her and catches her waist on the *arabesque*, supporting her balance. His left foot can come to a pointed or *demi-pointe posé* while his right foot remains flat.

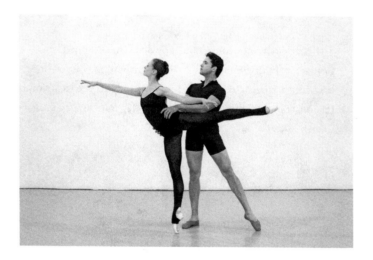

- When he is certain the lady is on her balance, the gentleman changes his grip from the *arabesque* so that his right arm wraps around the front of her waist and the left arm reaches over and around her left (*arabesque*) thigh.

- He then lifts her straight up in her *arabesque*, just a few inches off the ground, and she lifts up even higher in her upper body and back leg.

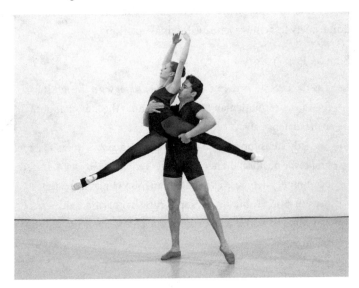

- The gentleman then lowers the lady down to a "dipped" position, almost horizontal with the floor, by bending his left knee back into a lunge. His right leg remains straight. The lady simultaneously bends her bottom (standing) leg into either a *passé* or *coupé* position.

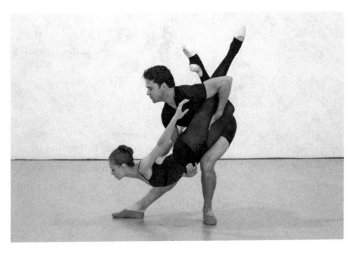

- When the dip has come all the way down into the fish, the gentleman pushes slightly forward in his hips, straightens his left knee, and lifts the lady back up again, guiding her back into a *first arabesque* position and then lowering her gently back *en pointe*. He uses his forward (right) arm to guide her position. The lady straightens her right (bottom) leg once again, making sure it aims directly underneath her, perpendicular to the floor.

Intermediate: Shoulder Sit

- The lady begins in a *sous-sus* fifth position with her right leg forward, directly in front of her partner. The gentleman stands in a *demi-seconde* position, supporting her at the waist with both hands.
- She rolls through her feet to take a deep *demi plié*, or *fondu* in fifth position and pushes off two legs, jumping straight up into the air with her legs in a tight fifth position, feet pointed.
- As the lady does her *plié*, the gentleman *pliés* as well and pushes against the ground, using the power of his legs to help lift her straight up into the air to just above his shoulder level.[5]

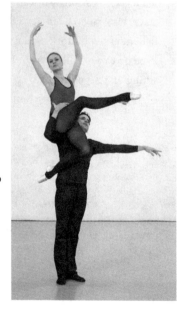

- Using the strength in his arms, the gentleman shifts the lady over to his right and gently lowers her down into a seated position on his right shoulder.
- As she is being lowered down to her partner's shoulder, the lady slightly pushes her rear end out backward into a sitting position and bends her two legs into a double *attitude*. Her right leg should be up to the front and

5 His hands should take the same position as they do for the straight *entrechat* lift discussed earlier.

her bottom leg down, resting against the gentleman's chest. He should keep a two-handed grip until he and his partner both feel secure; then he can try letting go of her waist with his left hand to support her with his right alone.[6]

Advanced: Torch Lift

- The lady prepares in a *plié* on her right leg, her left leg bent in *retiré*. Both legs should be parallel, not turned out.
- The gentleman should be positioned directly behind the lady, bent down (almost kneeling) on his right knee, with his left leg forward. He supports her balance with his right hand under her right buttock while gripping just below her left knee with his left. The lady should feel as if she is sitting on his hand.
- As the lady pushes strongly off her right leg, aiming straight up (not back), the gentleman stretches his back knee and comes into a standing position, lifting her straight up using both arms.
- As the lift is about to reach its full height, the lady stretches her left leg down strongly toward the ground, and the gentleman slides his grip down to her ankle while keeping his right palm flat under her buttock. Simultaneously she bends her right knee up to a parallel *retiré* position, maintaining the feeling of sitting on the gentleman's right palm. Her pelvis should be tilted slightly backward to give him a "shelf" to hold on to.[7]

6 Though this reduced support may feel scary at first, the lady must be careful not to collapse in the upper body, to look down, or to slouch backward. Any of these actions will change the gentleman's center of balance and could result in an accident.

7 While she is being lifted and at the height of the lift, the lady must not look down or pitch forward in her upper body at all. Tilting her head or upper body forward will immediately change the balance of the lift, making it very hard for the gentleman to hold on to her, and an accident could ensue.

Advanced: Back to Back with Over-the-Shoulder Grip

- To prepare, the dancers stand back to back, very close together though not quite touching. The lady has her upstage leg back, bent at the knee in a "B-plus" position.
- The gentleman takes a step backward with his left foot and bends both knees in a lunge. As the lady feels his body, she leans back slightly and wraps her arms over and around his shoulders.

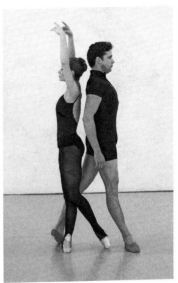 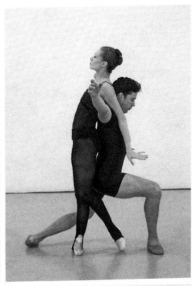

- When the gentleman is sure the lady has her arms wrapped securely around his shoulders, he leans forward in the torso and begins shifting his weight to his front (downstage) leg. As he leans forward, the lady uses her abdominal muscles to pull her legs in toward her and up off the ground.

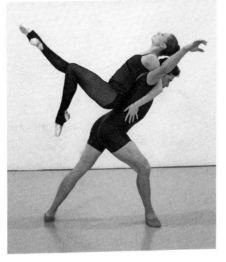

- At the full height of
the lift, the gentleman
is fully stretched in a
forward lunge, the lady's
weight resting balanced
on his back. The more
parallel his torso is to
the ground, the lighter
she will seem. The more
upright he stands, the
harder the work against
gravity will be on her
arms and abdominals
and his shoulders. The
lady's legs can remain
bent at the knee as
shown here, or one leg
can straighten, as the choreography demands.

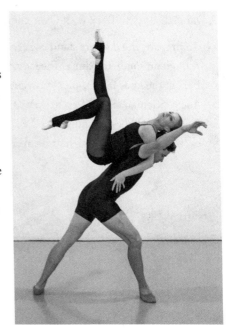

- To guide her safe descent, the gentleman twists his upper body
toward downstage, helping the lady reach the ground with her
feet as she rolls gently off his back. Then he can release her arms.
The lady must keep her abdominals engaged the entire time and
lower her legs with control. She must not allow them to drop
carelessly with the force of gravity, as the sudden weight could
injure the gentleman's back and both dancers' rotator cuffs.

Toss and Catch

Lifts that incorporate a toss usually involve a catch as well. These are
lifts in which the gentleman tosses the lady into the air, lets her go for
a split second, then catches her in a specified position. She may be
required to maintain her position in the air or to change it once he
lets go, depending on the step, the requirements of the choreography,
or both. In general, lifts and lift variations in this category range from
intermediate to advanced.

Intermediate: Toss up to a Catch in Fish Dive

- The lady prepares in a *sous-sus sur les pointes* in fifth position *en face* directly in front of the gentleman. He stands in a *demi-seconde* position with his hands at her waist.
- As the lady takes a deep *demi plié* in fifth to jump straight up in a tight *soubresault*, the gentleman *pliés* simultaneously and tosses her high above his head as she jumps.
- When the lady reaches the peak of the toss, the gentleman catches her with two arms wrapped around her legs, his right arm higher up around her lower thigh, his left arm lower down, just below her knees. The lady's rear end will rest lightly on the gentleman's upper chest.
- The lady remains in position as the gentleman completes the catch. He takes three steps forward diagonally (right, left, right) and switches the direction of the lady's position from *en face* to *effacé* by pulling back slightly with his right arm. From the last step forward right, he shifts his weight back to the left leg and finishes in a back lunge, the bulk of his weight on the back (left) leg.
- As the gentleman shifts his weight back into the lunge, he quickly changes his grip and brings the lady down into a typical fish position. (As he becomes more skilled, this change of grip can take place even earlier, during the three

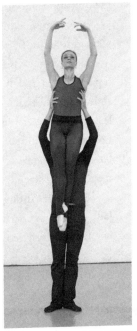

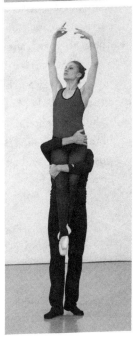

steps forward, to make
the transition smoother.)
His right arm slides up to
wrap around the front of
her waist to her opposite
hip bone, and his left arm
slides along her back (left)
leg as he lowers her into a
horizontal position. Her
left leg is now directed
diagonally upstage in an
arabesque line. Though the
lady will feel her partner
changing his grip to bring
her down, she keeps her
legs together and holds her
back up. As he brings her down into the fish position, she bends
her bottom (right) leg so that it hooks around his back and
keeps her left leg straight, directing it toward the upstage left
corner in an *arabesque* line.

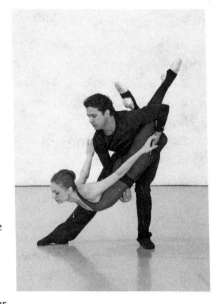

- The gentleman leans slightly into his back hip and tilts his upper
 body slightly forward so that the lady feels sandwiched between
 his upper body and his legs. If he has her wedged-in securely
 and she holds her back, hooking tightly around him with her
 right leg, he should eventually be able to let go of his grip with
 both hands, ending the sequence with his arms in an *à la seconde*
 position. This ending is always impressive and a proven audi-
 ence favorite.[8]

8 This toss and catch into a fish dive can also start from a standard press lift where
 the lady is "dropped" into position from above the gentleman's head. Once he
 finishes the full press, she must hold her position strong as he takes a *plié* in his
 legs, bends his elbows slightly, and, upon straightening his knees, tosses her a
 few inches higher into the air. He catches her on her way down, arms and hands
 immediately finding the standard grip for a "fish." The lady should maintain her
 position the entire time, holding her back strong until her partner has her se-
 curely tucked into the final fish pose.

Advanced: Running Fish Dives

- The lady prepares in the far upstage left corner in a *tendu croisé devant*, her left leg forward and right leg back. The gentleman prepares around center floor in a *tendu effacé derrière*, facing the lady with his right foot back in the *tendu*.
- The lady starts to run toward her partner in the center. When she reaches the approximate half-way mark, she *assembles* her *effacé* (or right leg) forward. As she lands the *assemblé*, she pushes strongly off two feet to propel herself diagonally to "fly" into the gentleman's arms. She can either keep her two legs straight or bring them into the fish position (right foot in *coupé* back) during her flight. She should aim the jump forward around the height of the gentleman's shoulders.
- As the lady jumps toward him, the gentleman responds by lunging forward into a long fourth position with his left leg forward in *effacé*, stretching his right arm forward to meet her body, and catching her around the front of her waist. His left arm catches her back (left) leg in an overhanded grip around her upper thigh.
- As the gentleman catches the lady, he should transfer his weight from his left leg to his right, ending in a lunge in an *effacé derrière* position toward the downstage right corner. The lady's upper body will now be supported not only by the gentleman's right arm but also by his upper right thigh.

Advanced: Catch to a Shoulder Sit from a Running Start

- The lady prepares in the downstage right corner of the room in a *tendu devant* with her right leg forward facing the upstage left corner. She stands diagonally across from her partner. The gentleman prepares by standing on center in a comfortable first position with his arms open *à la seconde*.
- The lady takes a running start toward her partner and, about halfway there, *glissades* forward with the left leg and jumps backward and up, aiming her rear end to land in a sitting position on the gentleman's right shoulder and turning herself halfway

around to face the corner she came from. Her legs should come to a standard double *attitude* shoulder sit position with the right leg up.

- As the lady takes off for her jump, the gentleman takes a step or two toward her as needed and bends down halfway to kneel with his right knee so that the lady can more easily reach his shoulder with her backside. He reaches out to catch her waist and helps her up to his right shoulder.[9]

- Once the lady has landed safely on the gentleman's shoulder (being careful not to tilt her upper body backward or forward), he can walk or turn around with her there, as called for, before lowering her back down to the ground in either a *sous-sus* or *demi-plié* in fifth position.[10] For a more advanced, alternative ending, instead of letting her down into a simple fifth position, the gentleman can bring the lady down from the sitting pose on his shoulder to a fish. To do so, he should mentally prepare to switch his grip while she is still perched on his shoulder. As he begins lowering her, his left arm quickly reaches over and around her left thigh as she straightens her leg into an *arabesque* and his right arm comes forward to hold her around the lower waist. The lady helps by changing the position of her body, back held strong, into a standard right-facing fish pose once she feels the shift in his grip. Her body should remain malleable, not stiff, allowing her partner to lower her all the way and place her in a secure horizontal position.

9 A safe, but admittedly less attractive, alternative is for the gentleman to catch the lady at the waist with his left hand as he reaches forward to take her bottom (left) knee with his right hand, pulling her into him so she can arrive safely in a sitting position on his right shoulder.

10 When both partners feel comfortable and secure, the gentleman can try letting go of the lady with his left hand to support her on his shoulder with his right arm alone. He can also try catching her with only the right hand, though this should not be attempted without a reliable spotter present.

Ballet Shoulder Sit from a Running Start
See a video demonstration of a catch to a shoulder sit from
a running start.

Complex

We have classified the following complex lifts separately, due to their high level of difficulty. Some require great physical strength, others more intricate actions—mainly quick switches of the gentleman's hands or of the lady's body position. As advanced level movements, these lifts are correspondingly riskier. *To avoid injury, dancers should have spotters present before attempting any lift in this category for the first time.*

Advanced: Side-Lying "Angel" Press

- The lady begins in a *tendu first arabesque* on her right leg, left leg back, facing the downstage right corner. The gentleman stands just a few steps diagonally upstage from her, matching her position. One or both of his arms are out to the side, and he faces her obliquely instead of standing directly *en face*.

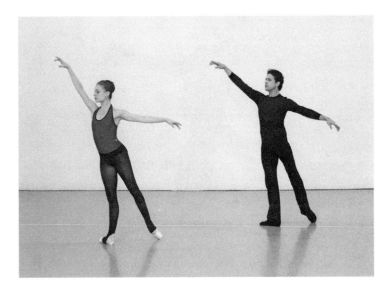

- The lady takes two steps toward him *en diagonal* (left, then right). On the third step she faces him and steps directly in front of him with her left foot, brushing her right leg up to a ninety-degree *battement*. If it helps the gentleman secure his grip,

the *battement* may be done to the side, *à la seconde*, or slightly more to the back, *à la "sebesque."* The lady brings her arms up to a rounded, high fifth position above her head if she chooses *à la seconde* or to a long *first arabesque port de bras* if she chooses *à la sebesque.*

- As the lady approaches, the gentleman spreads his feet slightly and bends down into a *plié*, ready to position his grip. As she steps in for the *battement*, he places his right hand on her left lower waist under her ribs with his thumb around her front and his fingers around her back and his left hand underneath her right thigh, right in the middle of her leg—not too close to her groin or knee.

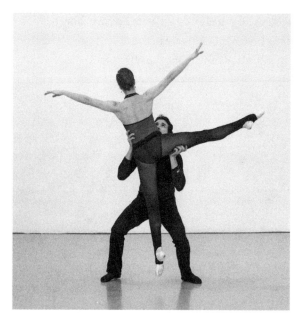

- To help with the upward momentum, the lady uses her *plié* to push against the floor as the gentleman begins to lift her. Using the strength in his legs and arms simultaneously he pushes her up into an overhead press lift, locking his elbows and shoulders. She should be directly over his head, not forward or back of him. As she is lifted in the air, she draws her bottom (left) leg up

to meet the top (right) leg; the bottom leg can be kept straight or bent into a *coupé derrière* or *retiré* position.

- Once he has her securely overhead, the gentleman can take a few steps to rotate her one full circle. He then slowly lowers her back down with control as she straightens her bottom leg vertically toward the ground to land in a *third* or *fourth arabesque en plié.*

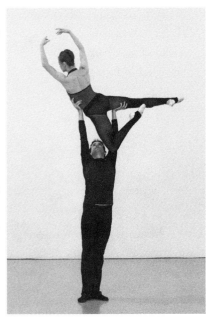

Advanced: *Tour* to a Fish Dive with *grand jeté* Preparation

- The lady and gentleman both begin on center, *tendu croisé devant.* Beginning with the front (left) foot, the lady takes four running steps forward to the diagonal downstage right corner. The gentleman follows close behind.

- The lady uses the fourth step on her right foot to push off into a straight-legged *grand jeté,* landing in *third arabesque.* The gentleman must have caught up to her by this point.

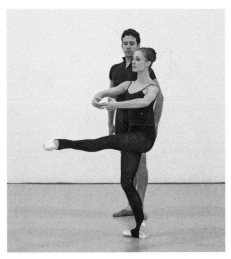

- As she lands in her *arabesque* position *en plié*, the gentleman positions his hands for the flip. His right arm wraps around her lower waist with his hand just above her opposite left hip, and his right hand wraps around the lower back side of her bottom leg just below her knee.

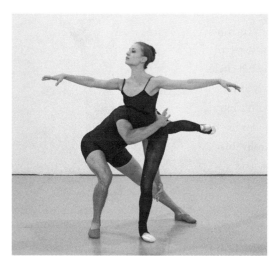

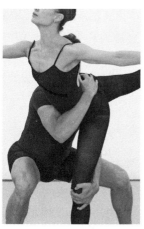

- Using mainly his right arm, the gentleman tosses the lady up into the air while pulling back on her leg with his left hand to initiate the flip. The rotation is *into* his body, not away. His right hand serves to support her back and continues the rotation.

- When the lady feels the gentleman initiate the flip, she first lifts her body and then helps by rotating her torso *en dehors*. Her arms come up overhead to a high fifth position as she does this.
- Once the lady has completed the full rotation, the gentleman slides his hands to catch her in a standard simple fish grip. Once his grip is secure, he lowers her as he lunges back on his left leg to complete the final fish dive pose.

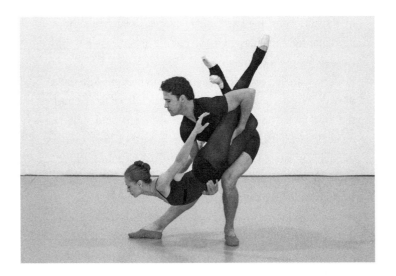

Lift and Flip Combination in Ballet
See a video demonstration of the described *tour* to a fish dive, similar to the one performed in the balcony *pas de deux* in John Cranko's *Romeo and Juliet* © The John Cranko Society.

Advanced: Helicopter

- The lady begins in the downstage right corner of the studio, facing diagonally toward the center in a *tendu devant* with her right leg in front. The gentleman stands on center in a comfortable first position with one knee slightly relaxed. One or both of his arms can be out to the side, and he can face the lady obliquely instead of standing directly *en face*.

- The lady runs to the gentleman *en diagonal* and, facing him, she steps directly in front of him with her left foot, brushing her right leg up to a ninety-degree *battement à la seconde*. She raises her arms to a rounded high fifth position above her head.
- As the lady approaches, the gentleman spreads his feet slightly and bends down into a *plié*, ready to position his grip. As she steps in for the *battement*, he places his right hand on her left lower waist under her ribs with his thumb around her front and his fingers around her back, and he places his left hand underneath her right thigh, right in the middle of her leg—not too close to her groin or knee.
- Pushing with his legs, the gentleman straightens up and tosses the lady over his head. As the toss reaches full height, he pushes slightly forward on her torso with his right hand and pulls back on her leg with his left so it passes over his head. He should try to do this in one smooth movement to make a counterclockwise circle. The lady maintains her position as he tosses her, torso straight up and leg held at a strong ninety degrees.
- As the lady's leg passes over the gentleman's head, he immediately lets go and switches his grip to catch her in a standard fish position, placing his right arm around her waist—his hand holding her left hip—and his left arm around her back (left) leg, which is up in *arabesque*.
- Once the lady is sure her leg has gone over her partner's head, she continues to bring it around to the front, her torso facing directly sideways toward stage right. Once her partner catches her waist, she brings herself into a *first arabesque* position with the right leg straight down and the left leg up to the back.
- The partners can end the lift here, in the *first arabesque*, as the gentleman places the lady gently down on her *pointe*. For an even more complex ending, though, the dancers can pass smoothly through the *arabesque* and continue into a standard simple fish pose as the lady bends her bottom leg into a *retiré* or *coupé* position. (See the "Ending in a Pose" section above.)

Advanced: Face-to-Face Overhead Press with Shoulder Support

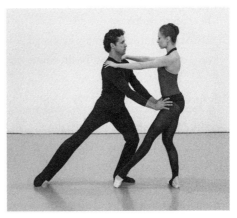

- The dancers begin facing each other at arm's distance. The lady has her left leg forward in *tendu* and her hands are placed on the gentleman's shoulders. She must be careful not to press down on his upper arms for leverage, which would hinder his ability to lift. The gentleman stands in a parallel sixth position or bends his left knee in *plié* with his right leg extended out in a *tendu derrière*. His hands are positioned on the lady's hips.

- The lady uses her left foot to step directly in front of the gentleman. Meanwhile, he positions his hands with their heels facing each other to make a flat shelf for the lady's hips.

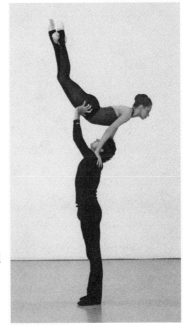

- The lady pushes off her left leg and crosses her legs behind her at the ankles into a double *attitude* position. If she needs to, she can press down lightly on the gentleman's shoulders for assistance. At the same time, the gentleman uses the strength of his *plié* to hoist her into the air above his head. As he lifts her, he should draw his elbows in close to his body and then straighten them to lock the lift into position.

- In descent, the lady begins softening her elbows as she feels the gentleman beginning to lower her, but she must not allow her legs to drop down suddenly. She must hold her back and abdominal muscles strong, keeping her legs in position for as long as possible so that the lift comes down with control.

Advanced: Forward Dive over the Shoulder

- The dancers start facing each other, standing at running distance. The lady stands stage left and the gentleman stage right.
- The partners run toward each other and, as the lady approaches the gentleman, she steps forward securely on her left foot and aims her torso horizontally past his downstage right shoulder. As she steps into him, the gentleman bends his knees and reaches forward to catch her, wrapping his right arm around her waist and positioning his upstage (left) hand flat underneath her right thigh.

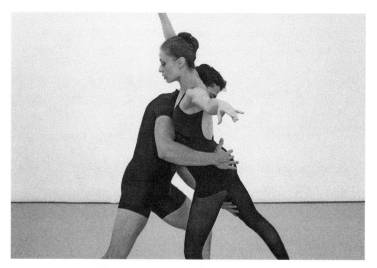

- The lady lifts her upstage (right) leg to *arabesque* and pushes firmly off the floor with her left, propelling herself over the gentleman's shoulder. As his right arm supports her waist, he uses his left hand (still on her thigh) to push her over his

shoulder. He keeps his hand there for support as he straightens his elbow and continues walking forward with her in position. As the gentleman lifts the lady, she sweeps her left leg up to the back to meet the right. Her right foot comes to a *coup-de-pied* position at the back of her left ankle.

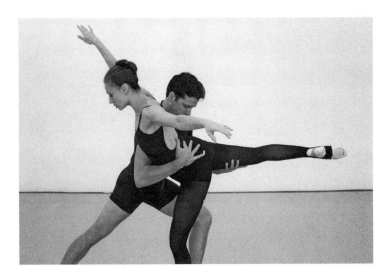

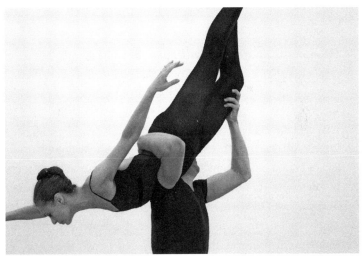

- At the full height of the lift, the lady should be upside down—with her legs up and her head down—and vertical, almost perpendicular to the ground.

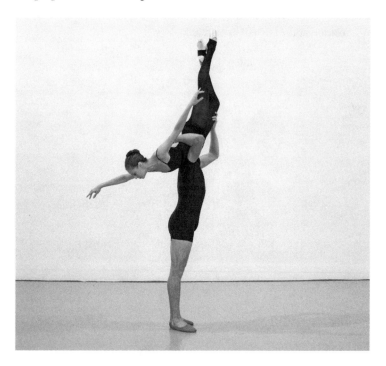

- In descent, the lady maintains her position while the gentleman lowers her back down in front of his body. She touches the ground with the left foot first and then steps backward on the right to steady herself and bring her torso upright.

Lifting is probably the most demanding aspect of partnering. It requires an abundance of practice, patience, and trust. As partners get to know one another and the initial timidity and apprehension subside, they will discover that lifting, tossing, and catching can be extremely exciting, incredibly rewarding, and a great deal of fun. Until confidence is firmly established between the partners, it will be wisest to have a spotter present, particularly when intermediate or advanced lifts will be attempted. Most important, instead of focusing

on immediate perfection and instant gratification, partners should try
to relish and enjoy the entire working and learning process together.

<p style="text-align:center">* * *</p>

Scan the following QR codes to view additional examples of complex
lifts as well as a mini *pas de deux*, which shows how it is possible to
link together several of the steps we have described in this book to
make one fluid combination.

Ballet Partnering Lift with No Arms
Demonstration of a hands-free balanced lift, from George
Balanchine's *Apollo* ©The George Balanchine Trust.

Flip from One Arabesque to the Other
Demonstration of a *tour* from *arabesque* to *arabesque*, com-
parable to that in the bedroom *pas de deux*, act III, of John
Cranko's *Romeo and Juliet* ©The John Cranko Society.

Back to Back Ballet Lift
Demonstration of an overhead lift using underarm support,
with a complex descent, from Douglas Gawriljuk's contempo-
rary *pas de deux*, "Entre Dos" ©Douglas Gawriljuk.

Combination of Moves in Ballet
Demonstration of Jennifer and Carlos' mini *pas de deux*
combination.

14

~

Cross-Training, Physical Therapy, and Injury Prevention

Exploring techniques designed to prepare the body for, and help it recuperate from, the physical intensity of partnering

We now want to share the advice and exercises we have found personally effective throughout our training and careers. Before you try any of the exercises described here though, we strongly recommend you seek the guidance of a dance medicine professional, a certified fitness expert, or both. We want you to be safe.

As longtime professionals we have come to realize that proper conditioning—both before and after intense partnering—has been nearly as significant to our *pas de deux* work as routine rehearsing. When muscles lack sufficient power, strength, tone, endurance, and fast twitch-response capabilities, partnering and repeated lifting can lead to strain and injury. While simple weight lifting exercises certainly make a good start, there are also other efficient and interesting ways to condition the body, both with and without weights. Some of the most useful exercises re-create the movements one makes while partnering, building the particular strengths necessary for *pas de deux* to work wonderfully.

Ballet-Inspired Resistance Training

Owner of Barrebox® Studios and creator of the Barrebox® BalletFit® workout, former Prima Ballerina Maria Teresa del Real has used her thirty years of professional dance experience to develop a cross-training program for dancers and pedestrians alike that, as she describes it on her studio's website (www.barrebox.com), "pulls directly from a dancer's 'tool-box.'" The exercises in her program come from the expert knowledge shared among dancers, their physiotherapists, and their master coaches. Carlos and I are constantly searching for inspiring ways to stay in shape offseason while enhancing our partnering work, so we both frequent the Miami Barrebox® Studio year round. We have found del Real's BalletFit® method particularly productive. It is structured to suit the needs of women and men, and we feel it has enhanced both our partnering capabilities and our overall physical awareness. By introducing and creatively intermixing several props—including the traditional ballet *barre*, weighted balls, and elastic Thera-Bands®—into a ballet-oriented exercise regimen, dancers' balance and alignment are doubly challenged during the workout. This heightened difficulty effectively mimics the physical demands that present themselves in work with a partner. Additionally the props require a dancer to hold his or her core solid and to stabilize the turnout on the supporting leg. Strength in the core and legs is crucial to both ladies and gentlemen during partnering. BalletFit® also prompts dancers to work on maintaining stability in their shoulder girdles and on building the overall muscular stamina necessary to help them stay *en balance* for extended periods of time, whether supporting a partner or being supported.

Sample Exercises

1. *Relevé.* This exercise involves raising and lowering the heel in an array of double- or single-footed positions, both with and without a *plié*—a bending of the supporting knee. *Relevés* may be done holding onto a *barre* or at center floor, incorporating a weighted ball. Elastic exercise bands suspended from the ceiling

or tied to the top of a door frame can also be used to provide light support. The bands should be pulled downward toward the ground as dancers raise their heels. Steadying one's balance against the resistance created is fantastic for building core strength and stability. These exercises can be frequently tailored to suit each dancer's unique and changing needs. For example, a sequence of *relevés* done in a *retiré* position will build strength for partnered *pirouettes* while those done in an *arabesque* position will more readily develop the stability needed for *promenades*.(Minimum repetitions: 8 each leg)

2. *Fondu* (with and without *relevé*). This exercise involves simultaneous bending and extending of both legs, done *en croix* or in each direction (front, side, and back). *Fondus* may be done center floor, holding a weighted ball for extra resistance. Practicing *fondus* while holding an elastic band fastened to various stationary structures for light support—a *barre*, the ceiling, a door frame—can intensify the challenge. *Fondu* repetitions work the hip rotators (turnout muscles), quadriceps, hamstrings, and lower abdominals, quickly and effectively building the stability and much-needed strength of the supporting leg. (Minimum repetitions: 4 in each direction with each leg)

3. Tricep pulls. These can be done with light free weights or elastic resistance bands tied to a *barre*. Using weights, the dancer stands with feet parallel, hip's distance apart. Knees should remain softly bent, and the torso should lean forward over the knees in a flat-back position. Starting with the elbows bent and the hands facing each other palm side forward, the dancer grips the weights at shoulder height. Keeping the elbows drawn in close to the torso, the dancer extends one arm backward without twisting it and then retracts it to the initial bent position, repeating the same motion with the other arm. Using a resistance band, the dancer loops the band twice around a *barre*, adjusting the length to make both sides as even as possible and taking one end in each hand. The dancer should take a few steps back from the *barre* and assume the starting position. The resistance will

be greater the farther away from the *barre* the dancer stands. The arm extension is done by pulling the elastic band backward while the torso and shoulders stay square to the *barre*. (Minimum repetitions: 10 each arm)

4. Bicep curls. These can be done using light weights or an elastic resistance band attached to a *barre*. Using light weights, the dancer stands with arms down, legs parallel, feet hip's distance apart, knees soft, and abdominals engaged. Gripping the weights with palms facing forward and keeping the elbow pressed against the torso, the dancer bends one arm up and then back down to work the bicep, repeating the exercise with the other arm. Using a resistance band, the dancer loops the band around the *barre* twice and takes one end in each hand. Facing the center, back to the *barre*, the dancer takes a couple of steps forward to assume the starting position. The resistance will be greater the farther from the *barre* the dancer stands. As the dancer bends the arm at the elbow, keeping it close to the body while pulling slowly upward against the resistance of the elastic, the bicep muscles will be appropriately challenged. (Minimum repetitions: 10 each arm)

5. *Pliés.* Facing the *barre* with the feet together and turned out at the heels in first position, the dancer loops an elastic resistance band twice around the *barre* and holds one end in each hand. The elbows should be bent so the hands meet mid-torso and the elastic is relaxed. As the knees bend in *demi-plié*, the dancer stretches the arms diagonally down and out, pulling the elastic equally on both sides. Next, the dancer straightens the knees and bends the elbows, releasing the elastic back to the beginning position. This alternating movement can be repeated eight to ten times with the legs in both first and second position. Like the *relevé* exercises, *pliés* are wonderful for increasing overall core stability and are also a great way to warm up the abdominals, back, legs, and shoulders. (Minimum repetitions: 16)

6. *Tendus.* Looping the elastic band around the *barre* twice and holding one end in each hand, the dancer faces away from the

barre, legs turned out in first position, arms down by the sides. As the right leg brushes outward into a *tendu devant* (front), the arms stretch forward up to chest height, pulling on the resistance band. This is repeated on both sides and *en croix* (front, side, and back). The arms follow the same pattern for *tendu derrière* (back). For *tendu à la seconde* (side), however, the arms are raised to pull the band up to shoulder height. This exercise is wonderful for building balance, core strength, and shoulder strength as well as for working the *latissimus dorsi* muscles of the back and for developing supporting-leg rotation and stability. (Minimum repetitions: 8 each direction with each leg)

7. Dancer sit-ups. These little gems are fantastic for toning the abdominal and oblique muscles while also enhancing timing and coordination. (Carlos and I find them much more stimulating than typical crunches.) The dancer lies flat on the ground, face up, legs stretched out straight in front. The legs should be rotated so the inner thighs are pulled together in a first position with the feet pointed. The dancer engages the abdominal muscles, pulling the navel in toward the spine to sit up. As the dancer sits up, he or she raises the arms and right leg into an *attitude croisé devant*. The dancer bends the raised leg with the knee pressed out to the side, keeping the foot lifted as high as possible. Both arms move through a rounded first position to end in a typical *attitude* position, with the arm opposite the raised leg rounded up above the head and the same arm as the raised leg out to the side, *à la seconde*. The dancer then lies back down, lowering both arms and legs to the original starting position. Repeat to the other side. (Minimum repetitions: 10 each side, for a total of 20)

8. Floor Wili. Inspired by the famous angel, or wili, lift in the second act of *Giselle*, this exercise is surprisingly difficult. Lying flat, face down to the floor, arms stretched out to the side, palms down, the dancer engages the lower abdominal muscles to raise the torso off the floor. The dancer also lifts the legs up off the floor, moving the body from a flat horizontal position into a "U"

shape. One leg remains straight while the other comes to a low *coupé derrière* or *cou-de-pied* placed lightly behind the supporting ankle. The same arm as the bent leg will move to an overhead position while the opposite arm remains out to the side. The dancer then lowers down to repeat the exercise on the other side. While this exercise is certainly beneficial for ladies—it is great for building the strength necessary to maintain one's position in several types of overhead lifts—gentlemen may also find it useful for toning and strengthening the crucial lower abdominal and back muscles. (Minimum repetitions: 5 each side, for 10 total)

9. Plank. Wonderfully useful for both sexes, this popular yoga pose actively engages the entire body, helping dancers quickly build strength in their arms, shoulders, backs, wrists, quadriceps, and abdominals. It is also a fantastic warm up exercise. Starting on the hands and knees with the wrists directly below the shoulders at a ninety-degree angle, the dancer spreads the fingers evenly forward with the palms flat on the ground. Engaging the muscles of the abdominal wall, the dancer presses firmly down into the palms and extends the legs straight back. The body should now be aligned horizontally from the top of the head to the heels, with the neck in neutral position. The hips should neither be raised nor tucked but remain neutrally aligned (essentially the starting position for standard pushups). The balls of the feet press into the floor while the heels remain lifted; the backs of the heels point up to the sky, and the underside of the heel pushes backward, opposite the toes. Once in position, the dancer tries gently to slide his or her shoulder blades down, elongating the back of the neck. The legs should be straight and actively engaged, but not hyperextended at the knees. Holding the pose, the dancer concentrates on breathing slowly and evenly for one minute, at which point he or she can relax down into child's pose for one minute before repeating the movement. (Child's pose is a restful yoga position that stretches the hips, thighs, and ankles. It is done by lowering to a hands and knees

position and resting the buttocks on the heels while keeping the knees spread and big toes touching.) (Minimum repetitions: 1, held between 30 and 60 seconds)

10. *Port de bras.* Using handheld or wrist weights, the repetition of standard ballet *port de bras* helps build the arm, shoulder, and back strength necessary for both men and women in partnering. Standing with the legs and feet in first position, arms down and rounded *en bas*, and keeping the abdominals actively engaged, the dancer moves one arm at a time through first position, rounded in front of the navel, up to fifth position, rounded overhead, open to second position, out to the side, and back down again to starting position, rounded *en bas*. This can be repeated with the other arm and then with both arms simultaneously. These *port de bras* can be done both *en dehors* (circling outward) and *en dedans* (circling inward). Another variation on this exercise involves moving the arms up through a first (or a high fifth) position and then following through to an *arabesque* (one arm extended straight in front and the other out to the side). The *arabesque* variation is exceptionally beneficial for increasing shoulder and wrist strength (the lateral muscles will be directly targeted when this is done from an overhead fifth). Strong shoulders and wrists are essential for successfully executing partnered *promenades*. Women may also find that weighted swan *port de bras* (where the shoulders are kept pressed down and back while the lady gently flaps her arms up and down, leading with the elbows and following through with the wrists) to be an unusual, fun way to strengthen the back, arms, and shoulders. (Minimum repetitions: 8 each arm or 8 total if both arms are working simultaneously)

Kettlebell Training

As described in the second edition of *So, You Want to Be a Ballet Dancer?*, kettlebell (KB) training can be a wonderful tool for enhancing one's partnering work, not only by building muscular strength

and stamina but also by building awareness of the physics involved in partnering. In addition to developing core, shoulder girdle, and leg strength, swinging a KB obliges dancers to judge its weight, force, momentum, and pull in the same way they would have to judge those of a partner. Using the kettlebell, dancers can learn how best to work *with* (rather than against) these physics, mastering them to their advantage. As dancers learn to use the entire body to move the KB through space, they learn to apply similar physical concepts in partnering. Former dancer and current fitness expert Michelle Khai, BS, CSCS (Certified Strength and Conditioning Specialist), believes in KB training so much that she developed her own dance-based KB program, Kettlenetics™. She has trained dancers from both the New York City Ballet and Miami City Ballet companies—including Carlos and me—helping them condition their bodies not only in the interest of improved partnering but for the overall wellness of their instruments. In demonstrations she has presented at IADMS (International Association for Dance Medicine and Science) conferences, and in our personal training sessions together, she has stated that KB training is "an ideal modality to help dancers prepare for the reality of their performance context."

Sample Exercises

1. KB swing. Executed precisely and correctly, KB swings build overall strength, power, and balance, with the added benefit of improving the dancer's cardiovascular endurance. Gripping the KB lightly, the dancer primarily uses the hips, glutes, quadriceps, and core—not the arms—to swing the bell. The dancer swings the KB from between the thighs up to the chest, emphasizing the major muscles along the back side of the body: all the way down from the heels, up through the hamstrings to the glutes and low pelvic region, and continuing up through the spine and neck. The dancer begins standing tall with feet hip-width apart, chest up, and shoulders back and down. The KB sits on the floor, upright between the dancer's feet. The individual should test the weight of the KB, keeping in mind

that it should be heavy enough to create a challenge but not so heavy that the dancer is unable to maintain proper technique. The dancer squats down and takes hold of the KB, gripping it with the palms facing into the body and the thumbs wrapped loosely around the handle. KB in hand, the dancer slowly stands tall, keeping the KB down, arms long, retracting the shoulder blades, and engaging the abdominals. The knees should be soft, not locked, with the bulk of the body weight shifted back into the heels (a foreign sensation for most ballet dancers). The dancer then bends forward with a flat back, pushing the buttocks down and out toward the back wall and engaging the glutes and hamstrings. The outer sides of the lower arms rest on the inner thighs, and the KB should now be hanging slightly behind the body. The dancer thrusts the pelvis forward explosively, driving through the heels and through the hips and, with arms extended, sending the KB swinging upward up to chest height. The gluteus should be squeezed tightly and the abdominals fully engaged at the height of the swing. The KB should be suspended almost weightlessly in the air for a split second before gravity begins to pull it back down. As the KB descends, the dancer allows his or her weight to shift back into the heels while hinging at the hips to guide the KB back between the legs to return to starting position. (Minimum repetitions: 8–10)

2. Clean and press. This common KB exercise combines both upper and lower body strength. Phenomenal as a total-body workout, it builds remarkable core strength and cardiovascular endurance. Standing with feet hip-width apart, the dancer picks up the KB with one hand and, while keeping the back straight, allows it to swing down between the legs. The palm should face the back wall while the arm rests on the inner thigh of the same leg as the arm holding the bell. The dancer drives through the heels, pushing the arm forward with the leg and thrusting the hips forward as in the two-handed KB swing. The dancer swings the bell forward, up to chest height. As it reaches

chest level, the dancer retracts the elbow with the arm coming in to meet the body. The palm now faces the side wall, and the dancer allows the bell to flip over so that it now rests on the back side of the hand, in what is called rack position. Bending the knees while retracting the arm, the dancer brings the KB in so that the legs—*not* the arms, wrists, or elbows—absorb most of the impact of the weight. From the rack position, the dancer presses the KB straight up to an overhead position, straightening the knees and aligning the arm in a straight line from hand to shoulder. The dancer then lowers the KB back down into rack position by bending the knees and elbow and bringing the arm back in to rest against the torso. Using the power from the torso and legs, the dancer thrusts the bell forward and out, letting it swing gently back down between the legs. (Minimum repetitions: 4 each side)

3. Pendulum circles. This highly effective and gentle exercise is good for warming up and cooling down and can be especially useful for gentlemen who have to do lots of lifting. Pendulum circles can be practiced to relax the shoulder joints and overworked muscles of the rotator cuff or to gently warm up and improve range of motion when the joints feel stiff. With feet parallel and hip-width apart, the dancer bends forward at the hips to a flat-back ninety-degree angle (holding on to a chair, table, *barre*, or wall with one arm for support, if necessary). Holding a light weight or KB—about five pounds should suffice—while the arm hangs loosely down toward the ground, the dancer begins gently to make very small circles with the arm, feeling the natural pull of the weight as it begins automatically to swing like a pendulum. The dancer allows the momentum of the weight to move the arm around effortlessly, clockwise and counterclockwise. The movements should remain smooth and controlled the entire time. (Minimum repetitions: 10 each direction on each side, alternating arms between sets if desired)

Traditional Weight-Lifting Exercises

While all dancers benefit from performing weight-bearing and weight-free isometric exercises, gentlemen, especially, may want to take their conditioning routines further in terms of building strength and coordination. A program comprising a mix of traditional stationary exercises *and* those designed to move and travel while bearing weight will produce tremendous results. Weight-training programs realistically simulate the lifting patterns required in partnering more than a typical, everyday weightlifting regimen does. With a rich and varied weight-training program, the dancer's neuromuscular system will learn to productively activate in the context of movement (or choreography), surpassing the confinements of stagnant weight-bearing lifts. While the following examples of both standing and traveling exercises can be practiced by all dancers, we feel that they *do* target the areas most relied upon by gentlemen during partnering.

Thera-Band™ and Pulley Tower Exercises

This group of exercises should be done with an elastic resistance band tied to a stable structure at about head height or using a gym pulley tower with the pulley adjusted to a similar level. The resistance, whether weighted or not, should feel comfortably challenging, not overly burdensome.

1. Straight-arm pulldown. Standing facing the elastic band (far enough away so that when it is held it is semi-taut) or facing the pulley tower, the dancer takes hold of the elastic or pulley handle with his arm extended out in front, just above shoulder height. Feet should be set comfortably apart and abs tightly engaged. Keeping the elbow straight, the dancer pulls down against the resistance until his arm is down by his side, working the shoulder and the triceps. After holding the position for two seconds, the dancer raises his arm back up with control and repeats the movement. This is a great exercise for the shoulders, triceps, and lateral back muscles. (Minimum repetitions: 5-10 each arm)

2. Crossover. Standing sideways to the tower, the dancer takes hold of the end of the elastic band or pulley handle with the hand closest to it (the inside arm). With his arm outstretched diagonally to the side, the dancer adjusts his stance as necessary so that the elastic or pulley cable is taut. Feet will be set comfortably apart, core engaged. Keeping the elbow as straight as possible, the dancer pulls downward and inward across the chest against the resistance, working the shoulders and the pectoral muscles. After holding the position for two seconds, the dancer returns his arm to the starting position with control and repeats the movement. (Minimum repetitions: 5–10 each arm)

The following series of exercises should be done either with the elastic resistance band tied to a stable structure at foot level or with the weighted pulley tower adjusted to the lowest position and the weight set for a comfortable challenge.

3. Deltoid arm-raise. Standing sideways to the tower, the dancer holds the end of the elastic band or the pulley handle with the hand furthest from it (the outside arm). He adjusts his stance so that the feet are comfortably spread and the elastic or pulley cable is taut. Both arms will be down, with the outside arm crossing over in front of the body just slightly, core engaged. Keeping the arm straight and pulling against the resistance, the dancer raises it to shoulder level to work the deltoid shoulder muscles. After holding the position for two seconds, he lowers the arm back down to starting position with control. (Minimum repetitions: 10 each arm)

4. Upright row. Standing facing the elastic band or pulley tower, the dancer takes hold of both ends of the elastic, one in each hand, or he takes the pulley handle in both hands, palms facing down. The elastic should be tied so that both ends are of equal length. The dancer can also stand on the elastic instead of tying it, making sure again that the ends are of equal length. The dancer adjusts his stance so that the feet are comfortably separated and the elastic or cable is taut. With the core engaged

and weight in the heels, the dancer pulls up in a rowing motion as far as he can—up to the base of the chin, if possible—working the shoulder and the entire arm. The elbows should end up slightly higher than the hands. The dancer lowers the arms back to starting position with control and repeats the movement. The rowing motion is especially wonderful for strengthening the pectoral muscles. (Minimum repetitions: 10)

Standard Dumbbell Exercises

The following exercises should be done using weights that provide a comfortable challenge. Avoid using weights that are too heavy. Heavy weights build bulk, which isn't aligned with the dance aesthetic of the long, lean body. Lifting extremely heavy weights also puts a dancer at unnecessary risk for strain and injury.

1. Bicep curls. The dancer stands with a weight in each hand, arms down, legs parallel, feet hip distance apart, knees soft, and abdominals engaged. Keeping the elbow connected to the torso and the palms facing forward, the dancer bends one arm up and then back down to work the bicep, repeating the process with the other arm. (Minimum repetitions: 10 each arm)

2. Straight-arm forward lift. Holding one weight in each hand, the dancer stands with the arms down, legs parallel, feet hip distance apart, knees soft, abdominals engaged, and palms facing back. Keeping the elbow and wrist straight, the dancer lifts one arm slowly and with control up to shoulder height. The dancer holds this position for two counts and lowers the arm back down, repeating the exercise with the other arm. This exercise can also be done starting with the arm out to the side and lifting it to shoulder height and as far up as possible to the back, keeping the arm straight. (Minimum repetitions: 5–10 each arm)

3. Dumbbell "bench press." Lying on a flat bench or on the floor with the knees bent up, feet flat on the floor at hips width apart, the dancer holds a dumbbell in each hand, letting them rest them on the thighs. The palms of the hands should be facing. The dancer lifts the dumbbells one at a time to hold them out

in front, up toward the ceiling, shoulder width apart. Once at shoulder width, the dancer rotates the wrists forward so that the palms of the hands are facing away from the body. The dumbbells should be just to the sides of the chest, and the upper arm and forearm should create a ninety-degree angle. Exhaling, the dancer uses the pectoral muscles to push the dumbbells straight up, locking the arms at the top of the lift and squeezing the chest. The dancer holds this position for one or two counts, then slowly lowers the arms down. (Minimum repetitions: 5–10 depending on weight)

Standard Floor Exercises

1. Sit-ups. The dancer lies on the floor or on a bench, knees bent, feet flat on the floor hip-width apart, elbows bent with the hands clasped behind the head. Engaging the abdominals, the dancer sits up either halfway to a crunch position or all the way to a full sit-up and finishes by lowering back down to repeat the exercise. (Minimum repetitions: in full sitting position, 25, as the movement is hard on the hip flexors; 50 in the less strenuous crunch position)

2. Reverse sit-ups. The dancer lies face down on the floor or on a bench. If a bench is used, the dancer should align the hips with the short edge and lean forward off of it. A friend should be present to hold the dancer's legs down. The elbows are bent and the hands clasped lightly behind the head. Engaging the lower back muscles, the dancer lifts his or her torso up off the floor or, if using a bench, as high as possible. The dancer lowers down again with control to repeat the movement. (Minimum repetitions: 15–20)

3. Plank and push-ups. (See BalletFit® sample exercise 9 above for plank instruction.) Beginning in the standard plank position, palms flat on the ground, the dancer bends the elbows to lower the body with control as far down as possible, being careful not to sway. This can be done with the elbows out or back and the

arms close to the body. Once lowered down as far as possible while maintaining proper form, he or she pushes back up to starting position to repeat the exercise. (Minimum repetitions: 1–2 planks held for 30–60 seconds each; 10–20 push-ups)

4. Pull-ups and chin-ups. A horizontal bar secured a foot or more above the dancer's height is needed for these exercises. Though pull-ups and chin-ups are essentially the same, pull-ups are done with the hands facing away from the dancer, which works the back and biceps simultaneously. Chin-ups, by contrast, are done with the hands facing the dancer, and while they also work the back, they especially target the biceps and upper shoulders. The dancer grabs the bar with the hands placed slightly wider than shoulder-width apart and hangs all the way down, bending the knees and crossing the feet at the ankles if necessary so as not to touch the ground while the arms are stretched. The dancer pulls the body up until the chin is above the bar, holds for a count, and then lowers back down, holding the body steady and not allowing it to swing. (Minimum repetitions: 5–10, each exercise)

Traveling Weighted Exercise

The following coordination exercise mimics the dance lifting pattern of both a *grand jeté* and traveling *assemblé*. It should be done only under the supervision of a teacher, coach, or other physical fitness or dance fitness professional. For combined safety and productivity, the weights used should not be excessively heavy: the full weight should be limited to approximately half of what the dancer is normally capable of lifting.

Traveling overhead lift. Holding the weights vertically at waist height, the dancer begins in a typical *tendu croisé devant* with the left leg in front. The elbows should be drawn in close to the body. Keeping the weights in the same position, the dancer takes a step forward on the left leg (turned out, with both knees bent in *plié*) while maintaining an upright, straight spine. Most of the body weight should now be on the front leg. Pushing against the floor with the legs, the dancer

takes another step forward (now with the right leg) while straightening the elbows and extending the weights up above the head. Again, the back should be straight and forward oriented, neither arched nor tilted back. Keeping the arms positioned overhead, locking the wrists and elbows, and being careful not to let the weights waiver, the dancer takes two more steps forward, maintaining awareness of the direction and how he or she is using the floor underneath the feet. Bending the front (right) knee in a *plié* to make a lunge position, the dancer slowly lowers the weights back down to the starting position with control. (Minimum repetitions: 4 in each direction across the floor)

* * *

In addition to strength and coordination training we have also designed our conditioning programs to include less intense, non-weight-bearing therapeutic exercises as well as proper cooldown and relaxation techniques. We swim regularly and incorporate various yoga positions, Gyrotonic® techniques, and Pilates exercises into our mainstream cross-training routines, all of which seem to consistently serve our evolving needs. As we mature as dancers, we find it more and more important to listen closely to our bodies and respect the potential dangers of overuse and intense fatigue. Especially in partnering, if a dancer feels too exhausted to execute proper technique while working, then it is safest for both partners to mark, walk, or simply talk about the *pas de deux*, without dancing it out fully.

Though expectations abound in rehearsal scenarios with colleagues, directors, *repetiteurs*, and choreographers present, there are times when partners need to put the pressure to perform aside and make the wisest decisions about their own health and safety that they can. Should one dancer's muscles and joints fail midway through a dance due to fatigue, both dancers run the risk of serious injury. Partners should consider such gambles thoughtfully and make their choices accordingly. Performing onstage is always a unique phenomenon, with adrenaline often seeing even the most exhausted dancer through. Rehearsal, however, presents an entirely different situation.

Professionals, especially, must work *intelligently* with respect to the intense rigors and demands of their daily schedules. They must give themselves permission to guiltlessly and confidently proceed in the safest and most efficient manner possible, as long as they maintain their professionalism and remain true to the principles and integrity of the choreography. Physical therapist Elizabeth Maples, DPT, warns that "senseless injuries can both occur and recur at the most inopportune times, and in the seemingly strangest of moments, during partnering. Fatigue and insufficiently warming up can easily lead to injury in any area of the body, even those that seem unrelated to the actual partnering work." For example, running while supporting another dancer's full body weight overhead can put tremendous stress on one's feet, ankles, knees, and calves. Running carelessly with a lift while exhausted can easily result in a strained calf, a sprained ankle, or a torqued knee.

Regardless of how simple or undemanding a piece of choreography may seem, variables beyond human control always exist when two people partner. The most intelligent way for dancers to protect themselves (and their partners) is with proper preparation. A dancer is always personally responsible for being warm and ready to dance on entering a studio for rehearsal or the stage for a performance. This especially involves paying diligent attention to previous injuries or problem areas. Mental preparation such as visualization, which can enhance focus and mind-body connection, is also expected of dancers and is actually crucial for avoiding injury. At the very least, reviewing choreography prior to the rehearsal can help partners avoid making silly mistakes and fumbling. When two dancers commit to being focused and consciously clear their minds of all peripheral issues and distractions, they become more able to act (and react) intelligently on the spot. They make themselves accessible and mentally available to the dance and, most importantly, to each other.

A dancer's conditioning responsibilities do not end with a class, rehearsal, performance, or even a season. In fact, quite the opposite is true. Cool-down stretches, therapeutic baths, ice regimens, massages, physical therapy, and acupuncture are just a few avenues dancers

might consider post-performance, post-rehearsal, and off-season to recharge, relax, and rehabilitate. All of these therapies can counteract the intense stress absorbed by a dancer's body on a daily basis. Frequent partnering *will* tax a dancer's instrument in numerous ways, many of which may not be immediately apparent. A dancer may not feel the aftereffects of a demanding *pas de deux* until the body has cooled down completely and all pain-masking adrenaline has run its course. That's why a dancer is always wise to engage in effective therapeutic cooldown rituals. They provide substantial benefits for a very small investment. When dancers attentively keep their physical instruments fine-tuned and in prime condition, they will find themselves ready and able to meet every dancer's ultimate goal: the next opportunity to dance.

15

—

The Powerful *Pas De Deux*

*Understanding partnering's extraordinary significance
and the many rewards it offers*

Pas de deux work has unquestionably become our favorite part of
dancing. Though it can be incredibly frustrating, time and time again
working through each new phase of it together has taken our art-
istry to new levels, both as individuals and as a couple. All things
considered, we find nothing more gratifying than sharing the stage
together, consumed by the power of a great *pas de deux*. Appreciat-
ing how much work and commitment we have mutually invested to
get to the point of performance provides us with an overwhelming
and unparalleled sense of fulfillment. For better or worse we have
pledged allegiance to each other, as a team. We have unconditionally
promised to depend on each other, believe in each other, care for
one another, and dance for one another in the very best way that we
can. We have sworn to unfailingly give each other the very best of
ourselves throughout every second of the partnered dance.

It is a genuinely comforting feeling to know that in dancing a *pas
de deux* you are never alone. There is always someone's hand out-
stretched ready to accept yours and someone's eyes waiting anxiously
to meet your gaze. Partnering provides the ultimate tandem escape
into another world. As two dancers make a definitive commitment

to each other, the audience (and everyone else) disappears. External pressures and expectations seem to dissolve. All that exists are two partners fully submerged in the music and the dance. The result is a beautiful roller coaster ride of emotion, sometimes exciting, other times subdued. On occasion the undertone may even be abrasive, and often there won't be an explicit emotional suggestion at all. Paradoxically we sometimes find that our experiences dancing a plotless *pas de deux* will be the most profound. Within the abstraction, we are forced to engage differently, on a purely physical level, being to being. We are free to explore the strengths existing within the rhythms of physical suggestion, breath, and heartbeat, and we are obligated to remain intimately connected through our interpretation of the music.

Whatever the case may be, partnering has the incredible power to take dancers and their audiences on an epic journey. Each and every *pas de deux* an audience witnesses encompasses all the emotional remnants from a couple's first awkward day in the studio to their all-too-familiar falls and fumbles, from the hurdles of their inevitable injuries and abundant arguments to the trusting confidence they likely have struggled to gain. Undeniably each and every one of the dancers' experiences, the good and the bad, will richly contribute to the final product. These facets, reunified in the moment of the dance, eventually bring the dancers and their audience together in the magnificent, ever-evolving final phase of the *pas de deux*. It is a magic that cannot be replicated or fabricated. It can only be experienced firsthand, through the extraordinary freedom provided by the stage.

Acknowledgments

We extend our sincerest thanks to all of the professionals, many of them our personal friends and colleagues, whose input helped significantly to substantiate the premise of this book. We are so grateful to have been able to enhance it with their collective experience and expertise. Deeply appreciated are the efforts of Philip Neal, Leigh-Ann Esty, Maria Teresa del Real, Iliana Lopez, Franklin Gamero, Patrick Corbin, Didier Bramaz, Monica Llobet, Elizabeth Maples, Michelle Khai, and Paul Louis, who all took considerable time from their hectic schedules to contribute to this endeavor. We also thank our fellow dancers and many students for constantly inspiring us to share what we have learned and to continue striving to be better dancers ourselves. Last but most certainly not least we give especially heartfelt thanks to our dear friend Ronald Goldfarb, who has been our constant cheerleader through this project and others. His help, his support, and his constant faith in us have made an impact on our lives in more profound ways than he may ever realize.

Index

Page numbers in *italics* indicate illustrations.

Audible straining, 34n2

"Auto-pilot," partnering on, 12, 21

Awareness: body awareness, 46–47, 51–52, 88–89; male dancers and, 53n4, 54–55; self-awareness, 27, 44–57, 53n4

Back: "backseat driving," 45–46; back to back with over-the-shoulder grip, 119–20, *119–20*; *développé en avant* with off-balance lean-back, 82–83, *82–83*; injury, 52, 53n4; *latissimus dorsi* muscles in, 140; strength, 53n4

Bad breath, 73

Baking soda, 72n1

Balance: abdominal core with control and, 46–47; alignment and, 54–55; counterbalance, 23, 26, 47, 61, 62, 80, 87; hands-free balanced lift, QR Code, 135; with lifts and accidents, 118n6, 118n7; off-balance work, 77–87, 93; *promenades en balance*, 79; regaining, 48

Balanchine, George, 7, 87, 98, 108, 135; hand-to-hand grip, 12; legacy, 6, 8, 66, 67

BalletFit*, 137

Ballet-inspired resistance training: bicep curls, 139; dancer sit-ups, 140; floor wili, 140–41; *fondu*, 138; plank, 141–42; *pliés*, 139; *port de bras*, 142; *relevé*, 137–38; *tendus*, 139–40; tricep pulls, 138–39

Les Ballets Trockadero de Monte Carlo, 62–63

Ballets Russes, 5

Barber, Samuel, 60

Barrebox* BalletFit*, 137

Barrebox* Studios, 137

Baryshnikov, Mikhail, 8, 66–67

Battement, 111, 112n4, 114, 126, 130

La Bayadere, 3

Bejart, Maurice, 7

"Bench press," dumbbell exercises, 148–49

Bicep curls, 139, 148

Body, 49, 66, 140; body awareness, 46–47, 51–52, 88–89; odors, 71–72, 72n1, 73. *See also* Arms; Cross training; Eyes; Hands; Legs; Shoulders

Body language: criticism through, 43; eye contact, 31–32, 40, 51n2, 68; physical suggestion, interpreting, 32–33

Bonding, through music interpretation, 34–36

Bournonville, August (1805–1879), 2, 4–5

Bow (*revérénce*), 7

"B-plus" position, 109

Bramaz, Didier, 63–64

Breathing, 33–34

Bujones, Fernando, 8, 17

Calm, keeping, 48

Cambré, 50, 79, 91n1, 107; in partnered turns, 97; press lift into *cambré avec cou-de-pied*, 103–4, *104*

Caniparoli, Val, 8

Carreño, Jose Manuel, 17, 68–69

Catch. *See* Toss and catch lifts

Cavaliers, 1–2, 3, 4, 12, 16–17

Chaconne (Balanchine), 67

Chaînés into falling pose, 97, *97–98*

Charisma, acting and, 36–37

Chassé, 109–10

Chemistry, 19–20, 28, 30, 32

Chin-ups, 150

Chivalry, 24, 45

Cirque de Soleil, 9

Clean and press, KB training, 144–45

Clothing: leotards, 72, 73–74; *pointe* shoes, 4, 74, 89; rehearsal garments, 72–73; wrap-tie skirts, 74n2

Coda, xii, 1, 3, 4, 6

Cologne, 71

Commitment, 27, 45, 154–55

As longtime principal dancers of the internationally acclaimed Miami City Ballet, husband and wife team Jennifer Carlynn Kronenberg and Carlos Miguel Guerra have shared the stage in much of the company's diverse repertoire, dancing to critical acclaim at some of the world's most prestigious venues. They have had the pleasure of working firsthand with sought-after choreographers, and as frequently invited guest artists they have taught and performed at numerous noteworthy schools and companies, both in the United States and abroad.